SOUTHEND-ON-SEA

THEN & NOW

IN COLOUR

KEN CROWE

The History Press

This paperback edition published in 2015

The History Press
The Mill, Brimscombe Port
Stroud, Gloucestershire, GL5 2QG
www.thehistorypress.co.uk

British Library Cataloguing in Publication Data.
A catalogue record for this book is available from the British Library.

ISBN 978 0 7509 6502 6

Typesetting and origination by The History Press
Printed in China

CONTENTS

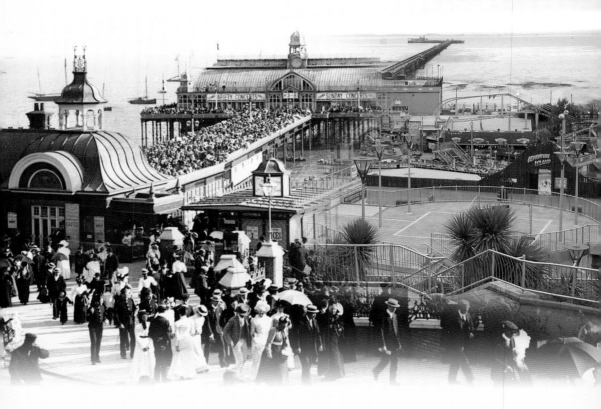

ACKNOWLEDGEMENTS

No work of this kind can be compiled without the generous support of many people. Principal among these are my colleagues at Southend Museum. Thanks are also due to Sue Gough and her colleagues at Southend Library, Local Studies Section, for their assistance in making all relevant resources available for research.

ABOUT THE AUTHOR

Ken Crowe taught history in a Southend comprehensive school before joining the staff of Southend Museums Service. His main interests are in the archaeology and local history of the Southend area, and he curates those collections at Southend Museum. He has a special interest in the history of the day-tripper from London in the late Victorian period and is the author of numerous history and archaeology books, including *Southend -on-Sea in Old Photographs* for The History Press. His hobbies include gardening, photography and holidaying in France.

INTRODUCTION

The photographs used in this book cover a period of about 140 years, from about 1870, while all of the 'present' views have been taken by the author during the early months of 2011. Many early views, which would certainly help to illustrate the history of the town over the past century or so, cannot be used in a work such as this because a comparative view from the same location cannot now be taken.

The earliest recorded use of the name 'South End' appears to have been in a will of one John Skott and dated 1481. The name is applied to 'a lane called South End', no doubt the same Southend Lane that is recorded on early maps and now known as Old Southend Road and Southchurch Avenue. This lane led to land at the southern end of the manor of Prittlewell Priory and rented out by the priory to tenant farmers. By the early eighteenth century the land along the seafront to the west was being developed, and at the end of the eighteenth century the Lord of the Manor of Prittlewell Priory and Milton Hall (Daniel Scratton) promoted the development of New South End by having the Grand Terrace and Hotel (later renamed Royal Terrace and Hotel) built on the clifftop to the west of the 'old' town. High Street was laid out as a private lane serving the new development.

The pier was built in the late 1820s, to take advantage of the growing paddle-steamer traffic in the Thames, which was followed in 1856 by the opening of Southend station, and then the building of the Clifftown estate to the south. The railway was also the vehicle which allowed thousands of 'trippers' from the East End of London to descend on the town from the 1870s onwards, particularly following the Bank Holiday Act. It was in about 1870 that the first of Southend's professional photographers set up business. The holiday traffic increased vastly following the opening of the second line to Southend, from Liverpool Street, with low fares as a result of fierce competition. It was this period, the decades either side of 1900, which saw an enormous growth in housing developments and in the resident population of the town. This period saw the rebuilding of the pier (1889) and the building of Victoria Avenue and a large number of hotels, together with the opening first of the Marine Park and then the Kursaal.

The decade of the 1960s was one of great change, not just in Southend but in many parts of the country. Much of the historic heart of the town was demolished in the name of progress, the centre of the town was pedestrianised and huge office blocks erected at the southern end of Victoria Avenue, the main road to the town from the north.

In recent years there has been another spurt of refashioning. The pier entrance and adjoining Cliff Gardens have been rebuilt and, at the opposite end of the town, the (new) Victoria Circus is being remodelled. As this is being written there are plans to build a new museum for the town and a new library. And what will be the fate of the office blocks at the southern end of Victoria Avenue, many of which now lie vacant? Only time will tell.

MANNERS WAY

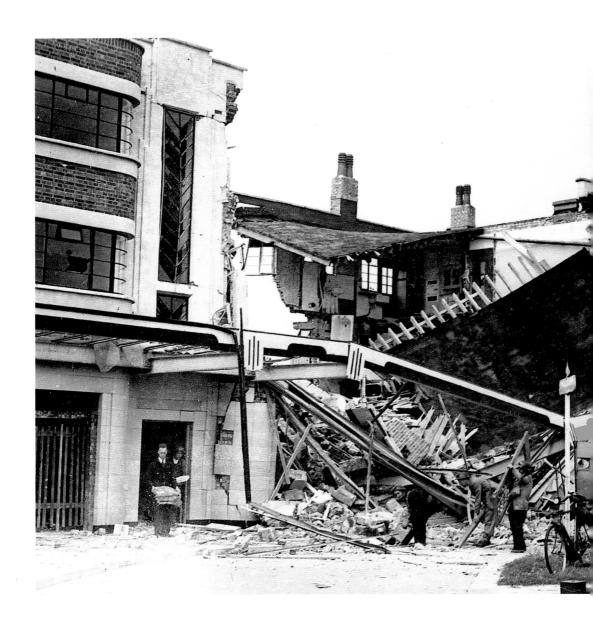

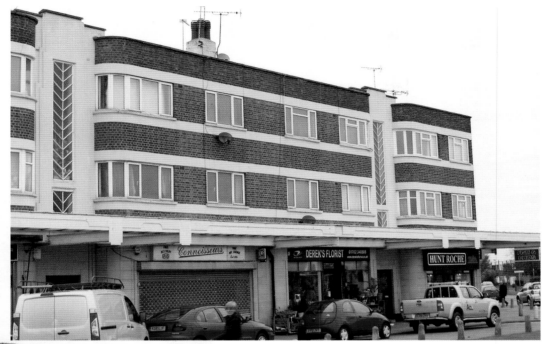

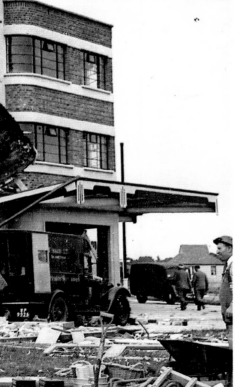

IN AUGUST 1940 the recently completed flats and shops on the corner of Manners Way and Oaken Grange Drive suffered a direct hit by an enemy bomber. This is unlikely to have been a deliberate target: the nearest targets were the airport (RAF Rochford) and the railway line. It may simply have been a case of the enemy offloading bombs before returning to the Continent after a bombing raid on London.

IN 1940 THERE were only two shops recorded in Manners Corner, the name given to these flats and shop complex. Ten years later all the shops were fully occupied, with a chemist, butcher, hardware dealer, baker, wine merchant, grocer, fruiterer, shoe shop and newsagent. While individual shops have come and gone, a very similar variety of businesses occupy Manners Corner today.

PRITTLEWELL & VICTORIA AVENUE

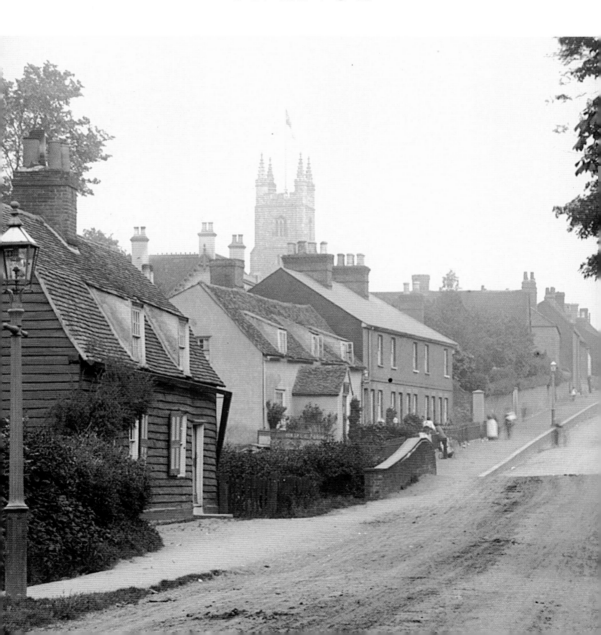

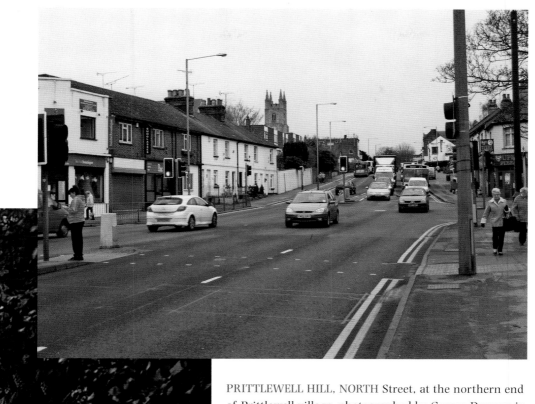

PRITTLEWELL HILL, NORTH Street, at the northern end of Prittlewell village, photographed by George Dawson in 1900. On the left of the photograph can be seen Glynd's Charity School (second building from the left), with the tower of St Mary's church just behind. Glynd's Charity School was established in 1727 by Lord of the Manor of Prittlewell Daniel Scratton and Thomas Case, for the education of ten poor children (originally only boys) of the parish. To the left (east) of the road was Prittlewell Priory and to the right was Earls Hall, together the two ancient manor houses of Prittlewell.
(Reproduced by kind permission of Southend Museums)

VICTORIA AVENUE WAS converted to a dual carriageway between 1967 and 1974 and is now an extension of the Southend Arterial (A127) road leading into the centre of the town. Apart from St Mary's church in the background, the only other buildings to remain from the earlier period are the row of brick cottages to the south of the site of Glynd's Charity School.

NORTH STREET

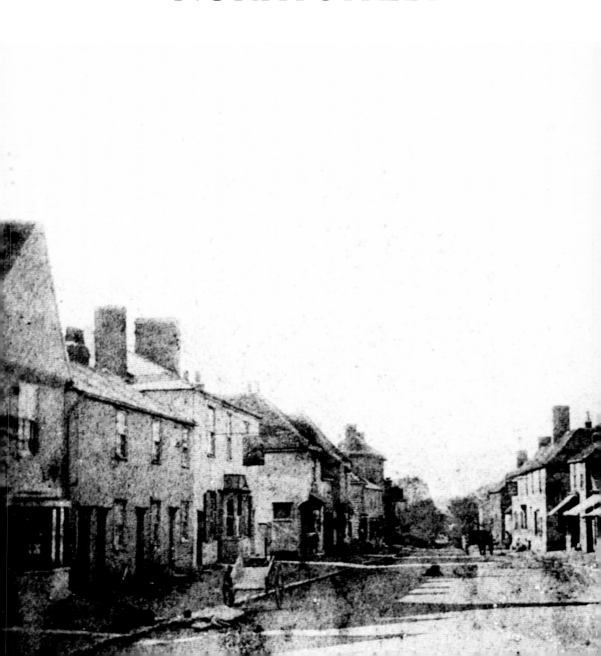

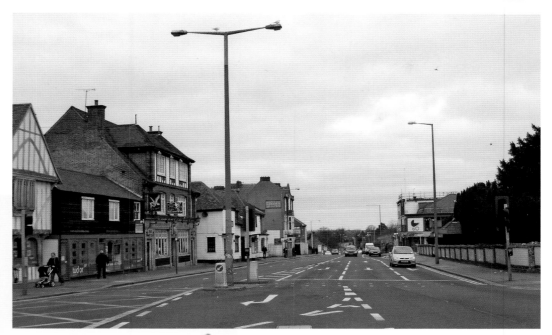

THIS FASCINATING VIEW of North Street, Prittlewell, in about 1880, looks north from the junction with East and West streets. At this time there was no Victoria Avenue linking the village with Southend and the only route to that modern town was via the original medieval roads. This view shows that at this date (and, in fact, largely until the 1930s) both sides of the road were crammed with medieval and later buildings. The buildings on the right are in front of the parish church of St Mary's. *(Reproduced by kind permission of Southend Museums)*

PRITTLEWELL AND VICTORIA Avenue, looking northwards, with Swan Hall on the left, which is one of only two medieval buildings here to have survived into the twenty-first century. For many years the home of the Carlton Bakery, in 1998 the building was seriously damaged by fire. Subsequently it was surveyed and the interior partially excavated, and then Swan Hall was expertly restored to its medieval appearance.

11

PRITTLEWELL VILLAGE

PRITTLEWELL VILLAGE, SHOWING the church hidden behind houses fronting East Street and North Street, *c.*1920. Some of these houses were medieval in date, having been erected at

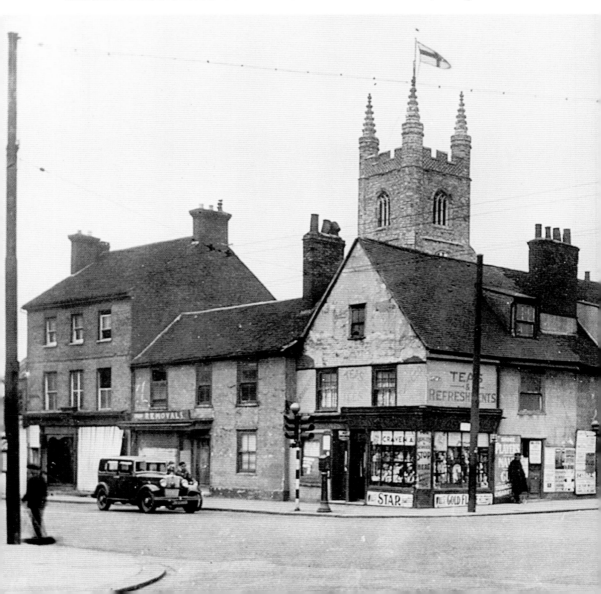

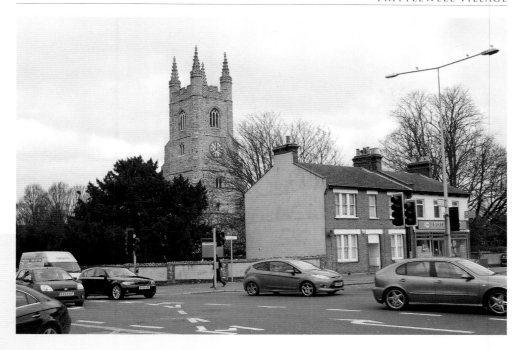

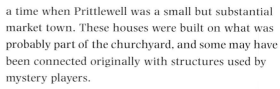

a time when Prittlewell was a small but substantial market town. These houses were built on what was probably part of the churchyard, and some may have been connected originally with structures used by mystery players.

(Reproduced by kind permission of Southend Museums)

IN THE 1930s all but two of the buildings on the south-west corner of the churchyard were demolished, following the so-called Prittlewell Improvement Scheme dating from 1912. Several of these buildings were probably of considerable historic and architectural interest, but Canon Gowing, vicar of St Mary's church from 1917, was determined that the view of his church should not be obscured.

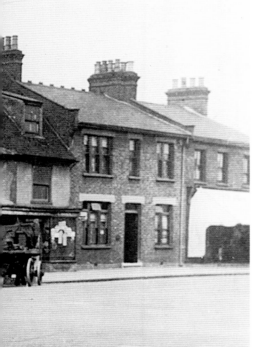

THE TECHNICAL SCHOOLS

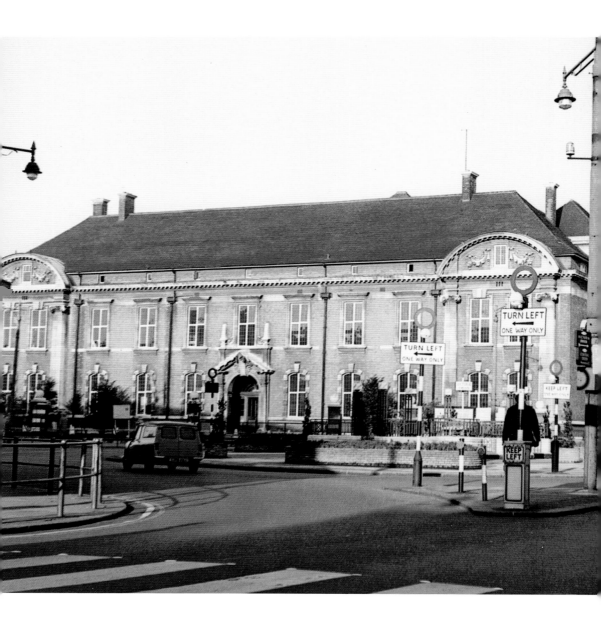

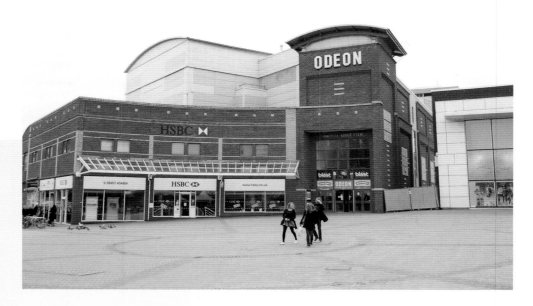

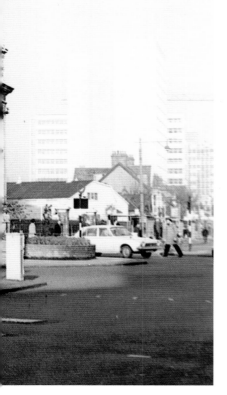

SOUTHEND TECHNICAL COLLEGE was opened in 1902. The architect was H.T. Hare, who also designed the public library (opened 1906) and Prittlewell School in Southend. The college replaced the old Southend Institute buildings in Clarence Road, which had been erected in 1884. In 1894 the municipal buildings had been erected on the south side of the Institute, and gradually the municipal work of the new council was such that they began to encroach on the educational establishment. Originally known as the Southend Day Technical Schools (for boys and girls), in 1913 the girls left to take up residence in new schools, and from that time the building was called the Southend High School for Boys. In 1938 the new boys' school was built in Prince Avenue. Once more the Victoria Circus building became the Technical College.
(Reproduced by kind permission of Southend Museums)

THE TECHNICAL SCHOOLS, otherwise known as the Municipal College, were demolished as part of the 1960s improvement scheme for the centre of the town. The site of the college remained vacant and was used as a convenient car park for many years. Eventually this corner of Victoria Circus was redeveloped with a series of restaurants and the new Odeon cinema, which opened in 1997.

COBWEB CORNER

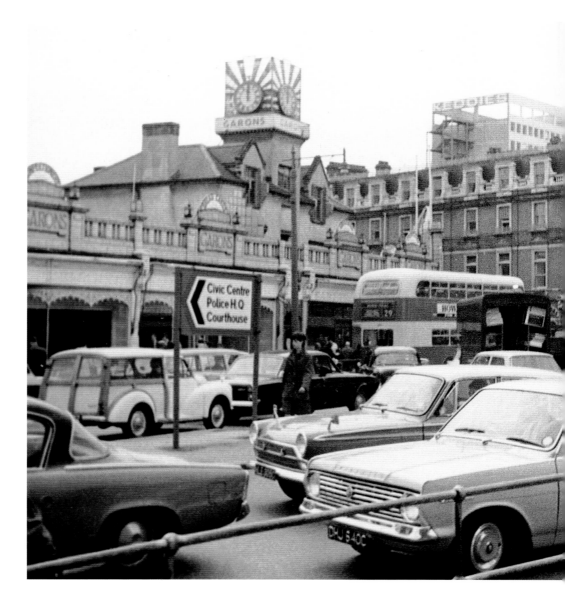

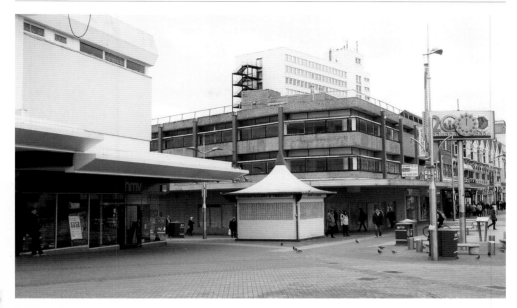

A VIEW TAKEN by Mr W. Wren immediately before the demolition of virtually all of the buildings seen in this photograph from the late 1960s. Originally known as Cobweb Corner because of all the overhead tram-wires, a later name for this area was Garon's Corner. This name was strictly applied to the north-east corner of Victoria Circus, for it was here that the large Garon's clock was visible from a wide area of the town. Although by this date the Garon's empire was past its peak, it once boasted a wide variety of retail shops – fishmongers, greengrocers, butchers, ironmongers, and so on – together with a cinema in High Street.
(Reproduced by kind permission of Mr W. Wren)

THE SKYLINE AT the northern end of Southend High Street and at Victoria Circus had been dominated by Garon's clock and the Hotel Victoria. Today, the 1960s Victoria Plaza (now renamed The Victoria) dominates the scene. In recent years the shopping centre has had a long-awaited 'makeover' resulting in a much more pleasant shopping experience and atmosphere. The pedestrianisation of Victoria Circus and the High Street has also resulted in a safer shopping experience although many would say that the 1960s architecture is no match for what it replaced.

THE HIGH STREET FROM
VICTORIA CIRCUS

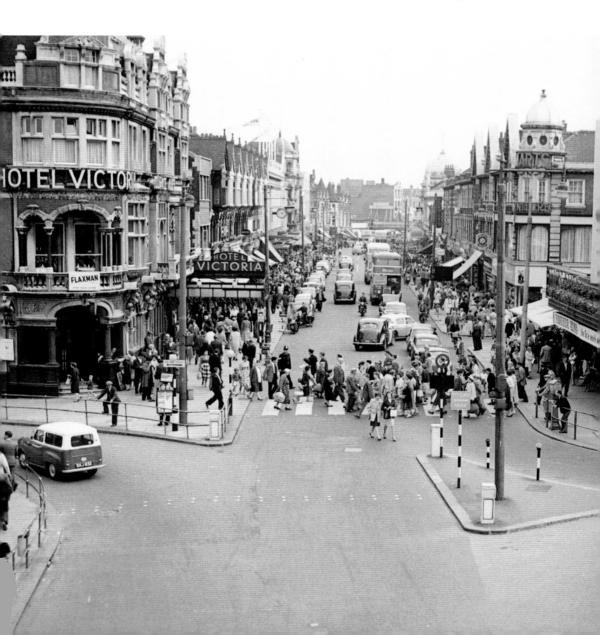

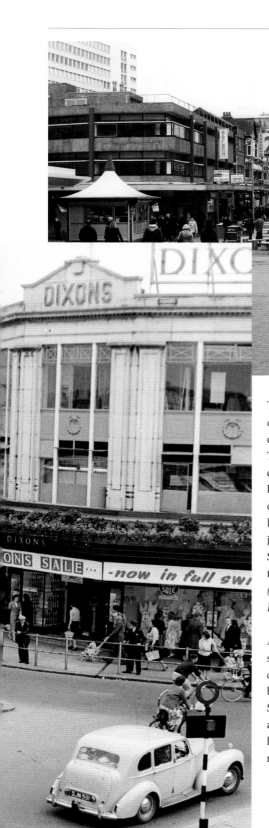

THE HIGH STREET, looking from Victoria Circus, c.1960. On the left is the Hotel Victoria, which was designed by James Thompson and opened in 1899. The hotel contained 100 rooms, each of which had electric lighting, and steam radiators on each floor kept the building warm in winter. On the opposite corner is Dixons, a family department store much loved by its patrons. Victoria Circus was at the junction of High Street and Victoria Avenue, with Southchurch Road to the east and London Road to the west.
(Reproduced by kind permission of Southend Borough Engineers Department)

ARCHITECTURE FROM THE 1960s dominates this scene today. Victoria Circus is no longer the historic crossroads for traffic as this role has now been taken by the ring roads to the north, which allow the High Street to be largely closed to traffic. The 1960s was a decade of great changes, not least to many of our larger towns. The historic hearts of many towns were ripped apart in the rush for modernisation.

19

KEDDIES

G.J. KEDDIE OPENED his first shop in Southend in 1892–3. In 1934 a new shop front with large columns was erected in the style of Selfridges of London. Keddies became one of the town's principal family-run businesses and one of the biggest department stores in the country. In 1960 Keddies opened the town's (and possibly the country's) first supermarket – SupaSave. Keddies rapidly expanded to take over the whole of the site once occupied by the Strand Cinema and Arcade. In 1987–9 the store was completely refurbished and revamped in order to counter the expected competition from the Royals shopping centre at the other end of High Street. (*Reproduced by kind permission of Southend Museums*)

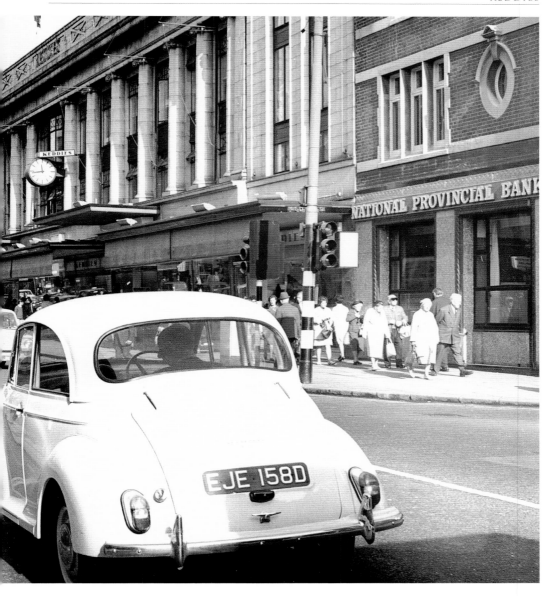

THE MUCH-LOVED KEDDIES store closed in 1996 and the building was soon divided into smaller units. The High Street frontage was first occupied by a Tesco Express store, then Gap and now Clinton Cards, together with a sports shop, clothes store and a chemist. The rear of the premises was also divided into smaller units, and the south-east corner is now occupied by restaurants. Much of the rest of the building is occupied by a Travelodge.

APPROACH TO CENTRAL STATION

GEORGE ATTRIDGE'S COTTAGE on the corner of Clifftown Road and High Street, had been sold for development in the mid 1880s, and Luker's Brewery had been replaced by the Astoria (later Odeon) cinema in the mid 1930s. The railway line, which reached Southend in the mid 1850s, was extended to Shoebury in the 1880s when the High Street bridge was built. By the end of the nineteenth century the whole length of High Street had been built up and had become the town's principal shopping street. In this view of the 1950s, Garons' Tea Bar occupies the corner plot, with the road leading to the railway station occupied by the offices of the local coal firms. *(Reproduced by kind permission of Southend Borough Engineers Department)*

ARCHITECTURE OF THE 1960s again dominates this corner of High Street and Clifftown Road. The coal offices and Garons' Tea Bar were swept away in the redevelopment of this corner in the late 1950s. One of the most notable contrasts between today and this area in the past is the scale of the architecture and the use of concrete as a replacement for brick and wood.

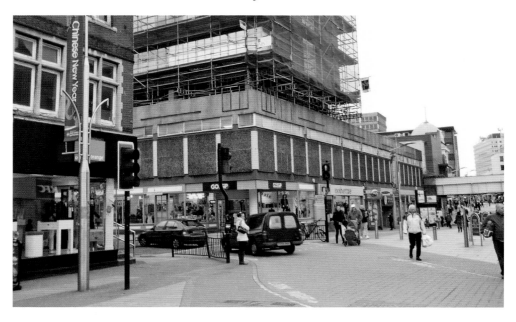

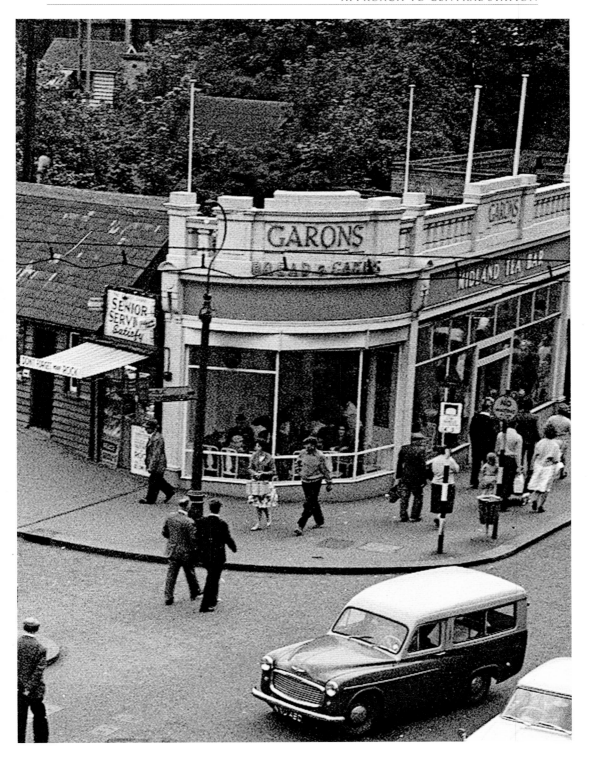

JONES'S CLOCK

ONE OF THE best-known stretches of High Street was that around the premises of R.A. Jones, whose shop was often called 'Jones's Clock' from the clock which can be seen in this photograph, dating from the early years of the twentieth century. Lipton's were at 74 High Street from the 1890s. In about 1912/13 the premises had been taken over by the British Shoe Company, and it was in their hands until 1928/9. By 1932 this was Lyons' Tea Shop, which it remained until the 1970s. Beyond Jones's shop was Heddles' Cash Clothing Stores and, beyond that, the London public house. (*Reproduced by kind permission of Southend Museums*)

SHOPS COME AND go, and what tend to remain are the façades of buildings above the shop frontages. This is well illustrated here. While R.A. Jones and

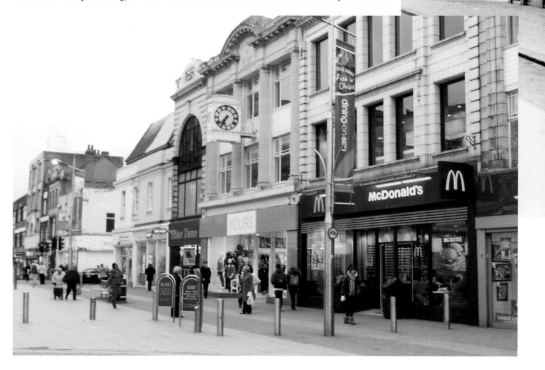

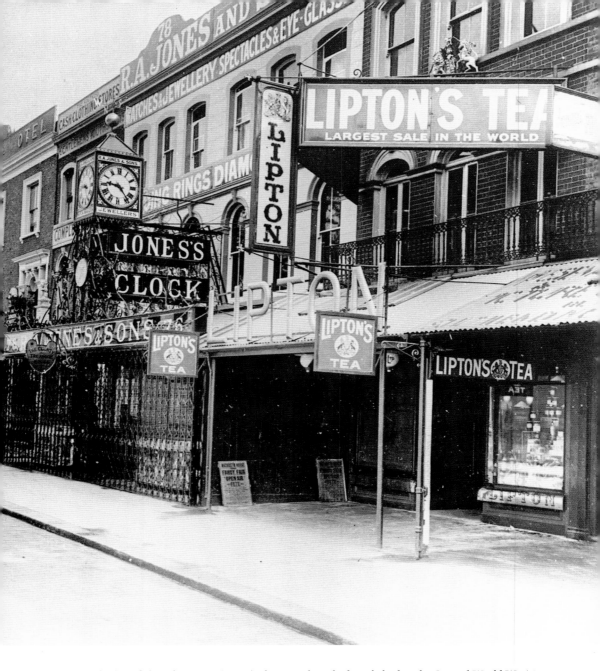

Lyons' café altered their frontages (Jones's shop was largely demolished in the Second World War) in order to modernise them, these have remained largely unaltered since. In fact, the name 'R.A. Jones' can still be seen in the stonework at the top of the building.

TYLERS AVENUE

THE AMBASSADORS THEATRE in Tylers Avenue
opened in the early 1900s. In 1927 Bram Stevens
appeared in a production of *Oliver Twist*. In 1931
it was converted to a cinema, opening as the Regal,
but by 1937 it had reverted back to the Regal Variety
Theatre, with such productions as *They're Off*, which
was described as a 'new revusical musical'. However,
the Regal continued to lose money and the theatre
closed in 1954.

IN 1963 BOTH the cinema and the adjacent fire
station were demolished. A new fire station was built in
Sutton Road. The properties on the north side of Tylers
Avenue have been replaced by the Southend County
Court and a Job Centre, while the area to the south is
now a car park.

27

THE GOLDEN BOOT

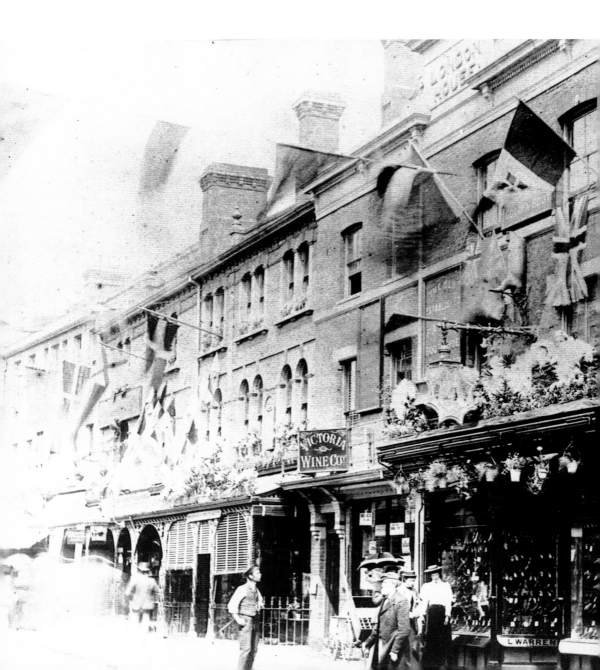

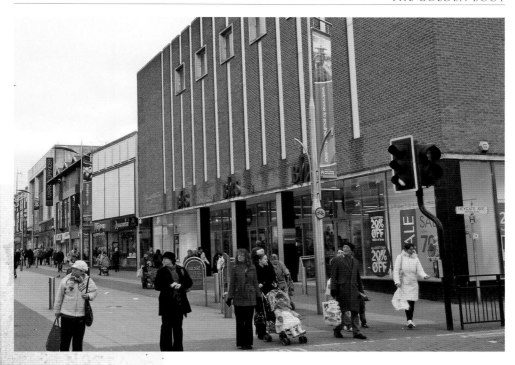

THE GOLDEN BOOT was, in the late nineteenth century, Southend's premier shoe and boot retailer. This photograph was taken in July 1881. The proprietor was L. Warren, bootmaker, although of course he did not make all of the footwear on sale. His neighbours in High Street were T. Belcham, corn chandler; Abraham Godward, seedsman, whose nursery shop was one of the first shops in High Street; John Currie, hairdresser and Charles Woosnam, wine merchant.
(Reproduced by kind permission of Southend Museums)

BY 1906 THE Golden Boot shoe shop had been replaced by the South Western Bank, with a dentist's occupying the first floor. The Victoria Wine Company was still occupying the premises at 38 High Street in 1937. In the following year British Home Stores opened their first shop on this site (40–44 High Street). Their new and much enlarged premises were opened in 1969, providing 70,000sq ft of floor area.

DOWSETT'S ROW

THIS ROW OF shops was built for Thomas Dowsett in the late 1870s, and this corner building was Dowsett's General Ironmongery, Pianoforte, China, Glass, Cutlery and House Furnishing Warehouse. Thomas Dowsett was Southend's first mayor in 1892. This remained Dowsett's shop (described as 'stationers' in *Kelly's Directory*) until 1906 when it was taken over by J. Black.

(Reproduced by kind permission of Southend Museums)

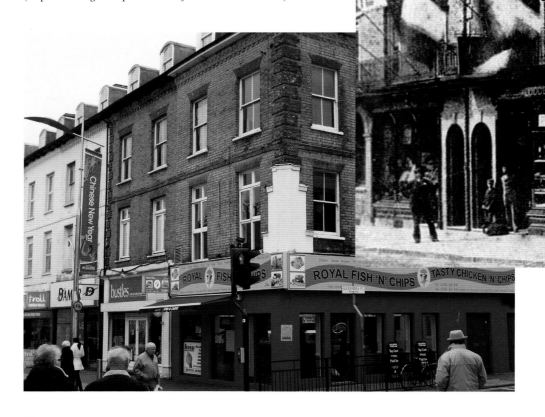

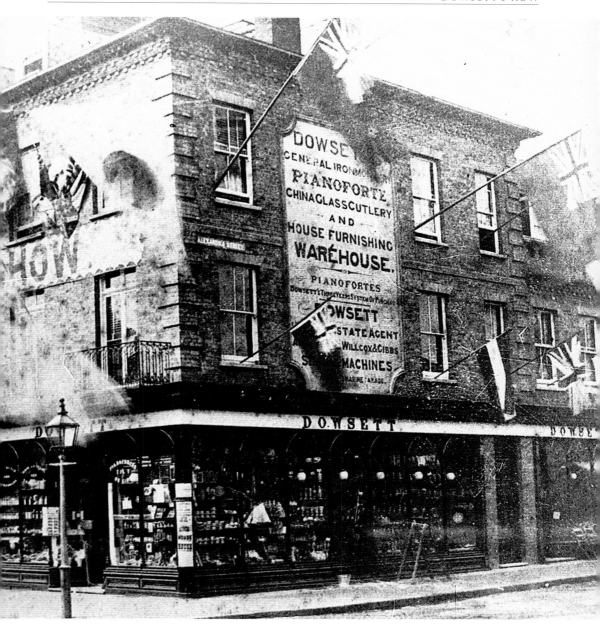

THIS IS TRULY a rare survival in our High Street: a row of mid-Victorian shops that have remained largely unaltered since they were built in the 1870s. First recorded as a fish restaurant in 1972, the corner premises still retains the original advertising board, although it is now painted out.

SOUTHEND
HIGH STREET

AT THE SOUTHERN end of Southend High Street, on the eastern side, were some of the town's premier stores and the first area of High Street to be developed for shopping. Here was Tipper's restaurant, described in 1899 as a 'Southend Mecca for single men – A Haven of Luxury'. Apart from its forty bedrooms ('equipped in the best taste') there was a ballroom with mirrors fitted all round, which could double up as a restaurant for up to 400 diners. On the first floor was the lounge, decorated in 'Moorish' style, with Axminster carpet and painted ceiling. To the north was

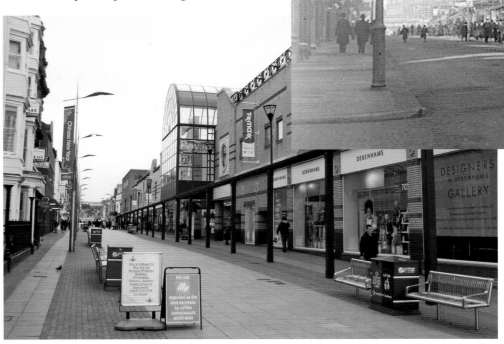

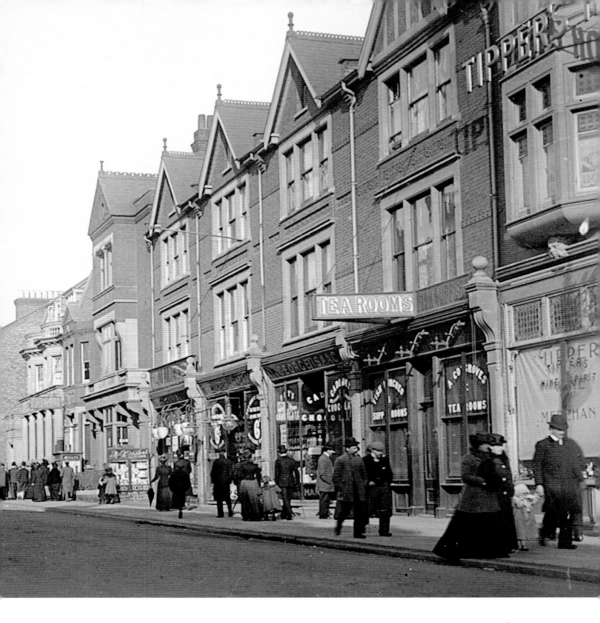

Cotgrove's restaurant and tea rooms, while further to the north were George Isaac's sweet shop (manufacturer of the first 'Southend Rock') and then the photographic studios of Alfred Shepherd. Further on still are the two early bank buildings with queues forming outside!
(Reproduced by kind permission of Southend Museums)

BY THE 1970s this area had become rather run-down, particularly since the opening of the Victoria Plaza (Hammerson) shopping centre at Victoria Circus. The whole of this end of the High Street was demolished in the early 1980s, including the two early bank buildings, to make way for Royals shopping centre. The name was adopted from the earlier buildings on the site: the Royal Library, the Royal Stores and the Royal Terrace, on the opposite side.

PROSPECT HOUSE AND THE NEW TOWN

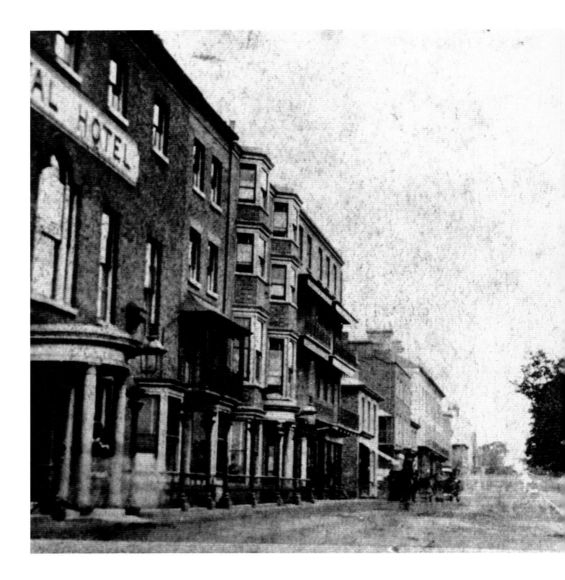

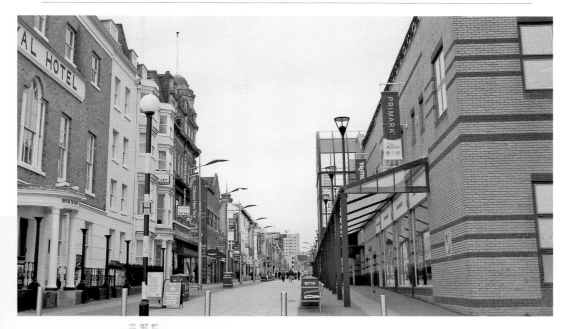

THE SOUTHERN END of High Street, photographed by Frank Secourable in about 1875. On the left is the Royal Hotel, and opposite is Prospect House, built in about 1820, the home of Elizabeth Heygate and later Warwick Deeping, the famous author. High Street had originally been laid out as part of the scheme for the New Town of Southend in the early to mid 1790s, but it did not become the town's main shopping street until the late nineteenth century. Until then it was still partly residential.
(Reproduced by kind permission of Southend Museums)

AMONG THE BUILDINGS to be demolished as part of the redevelopment of the southern end of the High Street was Prospect House. Other buildings to disappear in this redevelopment were the Ritz Cinema and the Grand Pier Hotel, the latter dating from the 1880s.

THE POST OFFICE

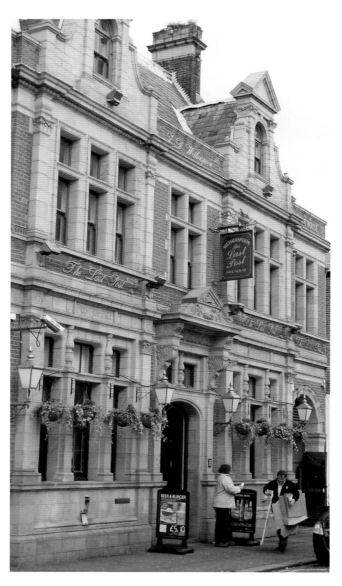

SOUTHEND'S FIRST GENERAL post office building, in Weston Road, was opened in 1896. Tenders had been invited for the building of the post office in May 1895. The new post office was built in the grounds of the old lodge, which can still be seen from the alley on the Clifftown Road side. The post office was to have a frontage of 50ft, the 'public room' being 37ft by 23ft wide. 'Here provision has been made suitable for the requirements of Southend probably for many years.' (From the *Southend Standard*, 23 May 1895.) *(Reproduced by kind permission of Southend Libraries)*

THE POST OFFICE closed in the late 1980s, being replaced by much smaller premises, first in the Victoria Plaza (Hammerson) shopping centre and then in High Street. The Weston Road premises were converted into a public house named, very appropriately, The Last Post.

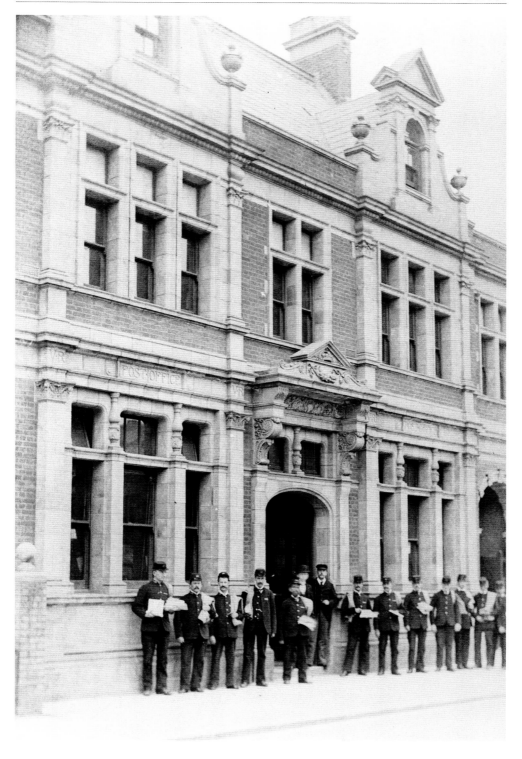

ALEXANDRA STREET

THIS PHOTOGRAPH OF Alexandra Street was taken during the Home and Atlantic Fleet's visit to Southend in 1909. The principal streets were decorated in suitable fashion. We are looking eastwards towards High Street. Alexandra Street was then relatively new, having been laid out in 1873, and together with High Street became one of the principal shopping streets in the town. In 1909 you could find the Singer Sewing Machine Co., Schofield and Martins, the Empire Theatre and the Victoria Temperance and Commercial Hotel here. *(Reproduced by kind permission of Southend Museums)*

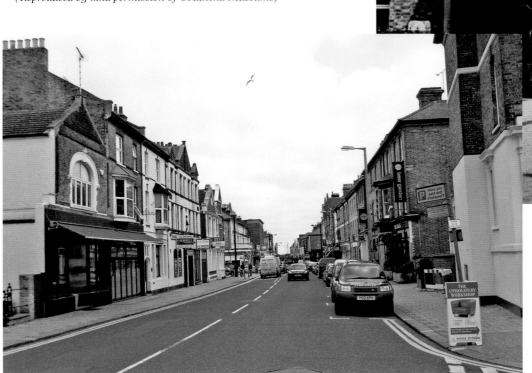

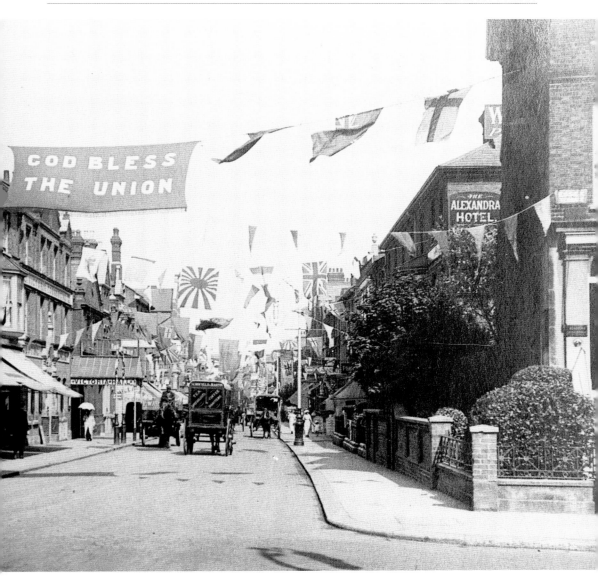

ALEXANDRA STREET HAS remained largely unaltered since the late nineteenth century. Until the early 1960s some of the buildings were used as local council offices and this area was, in fact, at the heart of local government. Although the old town hall building which stood in Clarence Road was demolished, Alexandra Street is certainly worth a visit for its architecture.

THE ROYAL HOTEL

THE ROYAL HOTEL IN High Street, with a coach and four standing at the entrance. The coach was driven by Percy (Stan) Gill – his father apparently ran the first horse-drawn bus service in Southend in the nineteenth century. Rather earlier, at the end of the eighteenth century, two coach companies vied for trade in the newly-expanding settlement, the journey from London taking about eight hours.
(Reproduced by kind permission of Southend Museums)

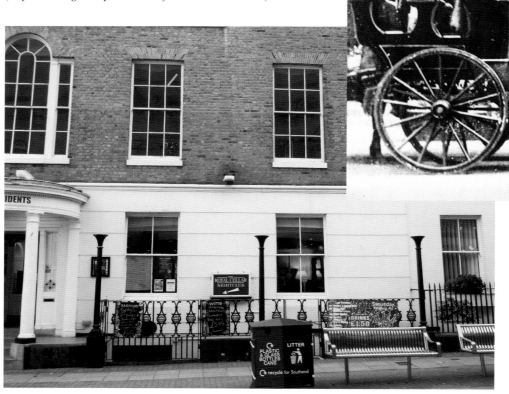

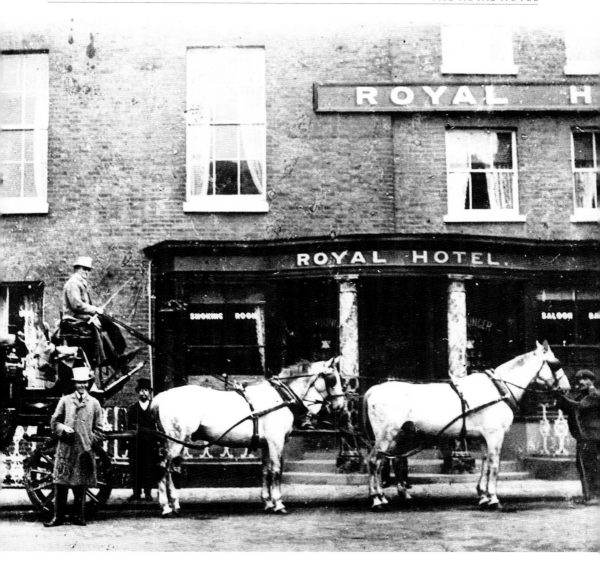

IN THE LATE 1960s, Courage, the brewers, had planned to spend £45,000 on the restoration of the Royal Hotel, but by 1974 it was suggested that the hotel should be demolished. Later that year Courage sold the hotel to Southend Council, and the building was extensively restored following a campaign by the Southend Conservation Society and reopened in 1983. The columned entrance seen on the right in the earlier photograph has been completely removed during the restoration of the buildings.

THE ROYAL LIBRARY AND GROVE TERRACE

A PHOTOGRAPH BY Frank Henry Secourable in about 1875, showing the Royal Library, with the corner of Grove Terrace just visible behind, and in the distance St John's church. The library

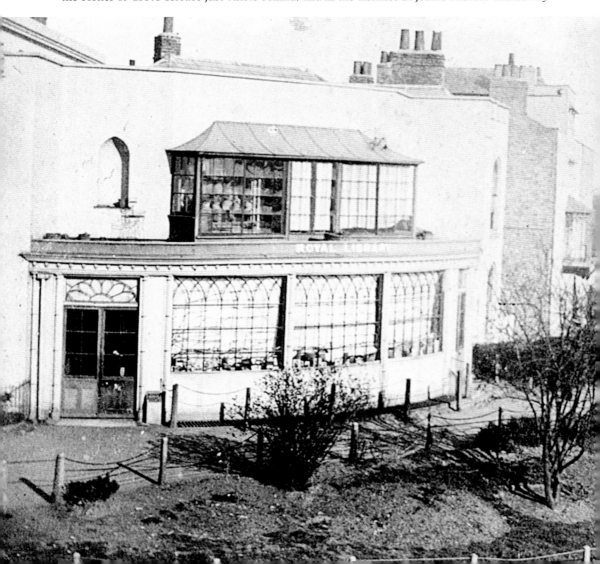

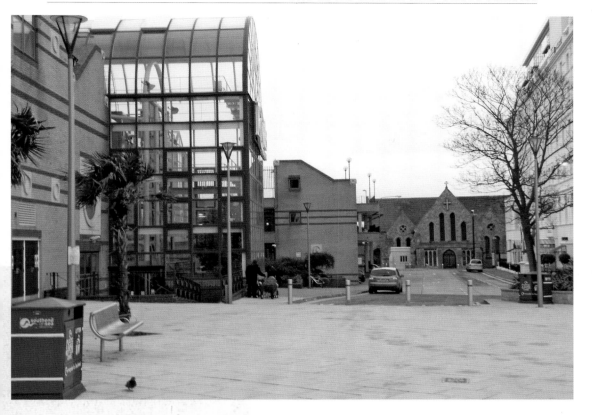

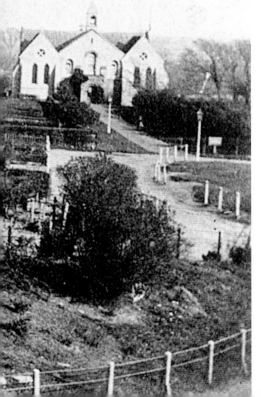

and Grove Terrace were part of the scheme for 'New Southend' and were built in the late eighteenth century, together with the Grand Terrace and Hotel, and High Street. St John's was built as the parish church of Southend and was opened in 1842 when Southend was created a parish in its own right. *(Reproduced by kind permission of Southend Museums)*

GROVE TERRACE WAS demolished in the later nineteenth century, certainly by 1880, and the old Royal Library building was refashioned. Public houses (the Grand Pier Hotel and the Royal Stores) occupied much of this site by the late nineteenth century. These, together with Prospect House and the buildings to the north, were demolished in the 1980s to make way for the Royals shopping centre. St John's church, now rather hidden behind the Royals and the Palace (Park Inn) Hotel, is the historic heart of Victorian Southend. The churchyard is especially worth a visit.

ROYAL TERRACE
AND HOTEL

ROYAL TERRACE AND Hotel were built in the early 1790s as part of the
scheme promoted by the Lord of the Manor of Milton and Prittlewell (Daniel
Scratton) for the creation of a 'New Southend'. It was hoped to attract
more genteel visitors to the growing town by providing accommodation
more in keeping with their refined tastes. However, the venture was not
an immediate success, and the whole estate was sold in lots in 1800. The
principal purchasers were the Heygate family. In the opening years of the
nineteenth century the terrace was visited by Princess Caroline (wife of the
Prince Regent), after which the terrace and hotel became 'Royal', and also by
Lady Hamilton (of Lord Nelson fame).
(Reproduced by kind permission of Southend Museums)

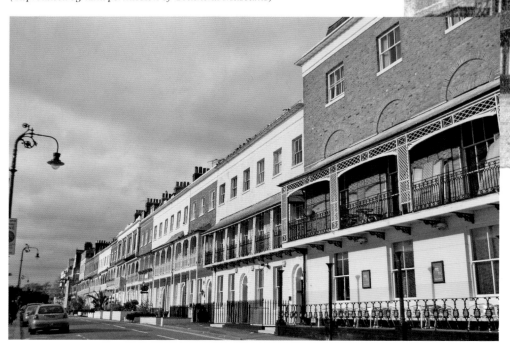

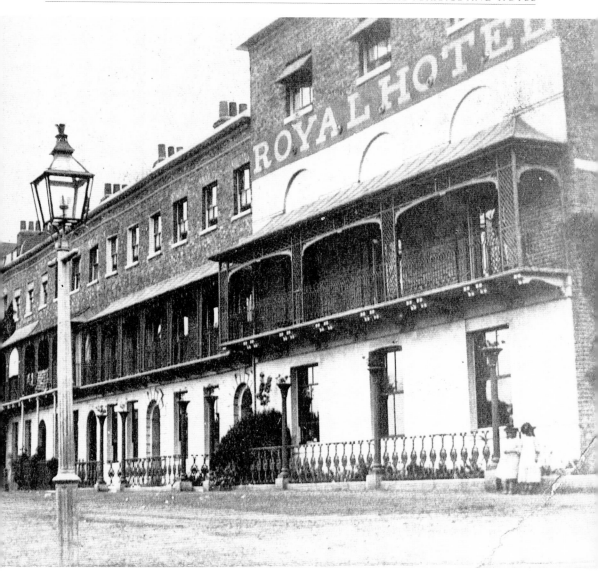

DURING THE SECOND World War, Royal Terrace was requisitioned by the Admiralty to become HMS Leigh, part of Thames Naval Control. In later years the buildings became rather neglected, and they were under threat of demolition by the 1970s. A successful campaign was launched in the town by the Southend Conservation Society to save the buildings.

NELSON STREET

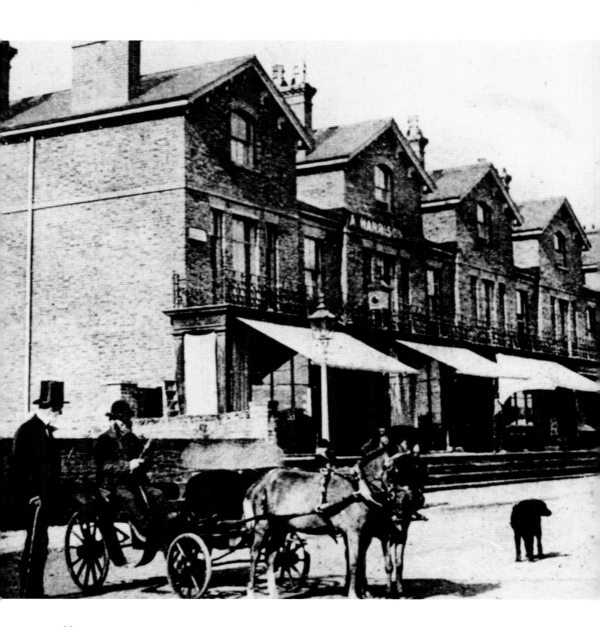

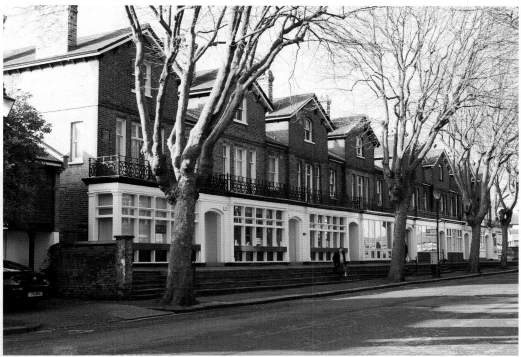

NELSON STREET, PHOTOGRAPHED by Frank Henry Secourable in about 1875. Before the development of High Street for shopping, Nelson Street was the principal shopping street in what was known as 'Upper' Southend (to distinguish it from the Lower Town, along Marine Parade). This area, Clifftown, was built between 1856 and 1861. It was designed by the firm of Banks and Barry and built by Lucas Brothers. Among the shops in this street were Fred Garon, plumber; George Gooch, grocer; John Fleming, poulterer; Charles Taylor, stationer and William Griffin, grocer.
(*Reproduced by kind permission of Southend Museums*)

TODAY ONLY ONE of the original shop fronts remains, that being at the northern (far) end of the terrace, nearest to the railway line. Although the layout of the street has remained largely unaltered, the majority of the premises have been taken over by solicitors' firms and now, far from being one of the busiest and most vibrant parts of the town, it is something of a quiet backwater.

CHEAPSIDE

ALTHOUGH WE DO not know the exact date of the photograph on the right, it was taken in about 1920 at the corner of Milton Road and London Road in Westcliff, when there appears to have been a flood. Crowds are watching a man paddling across the road. This small parade of shops, up to the junction with Milton Road, was known in the early twentieth century as Cheapside, the corner being Cheapside Corner, which was the premises belonging to Perhams in the first half of the century. The complex array of tram-wires at this junction is quite evident. *(Reproduced by kind permission of Southend Museums)*

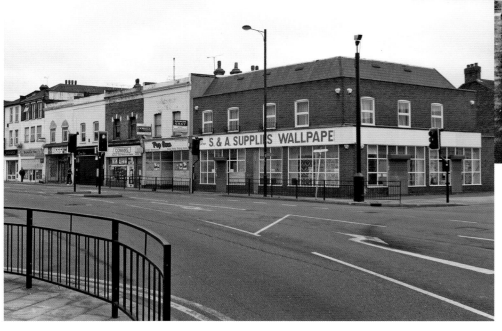

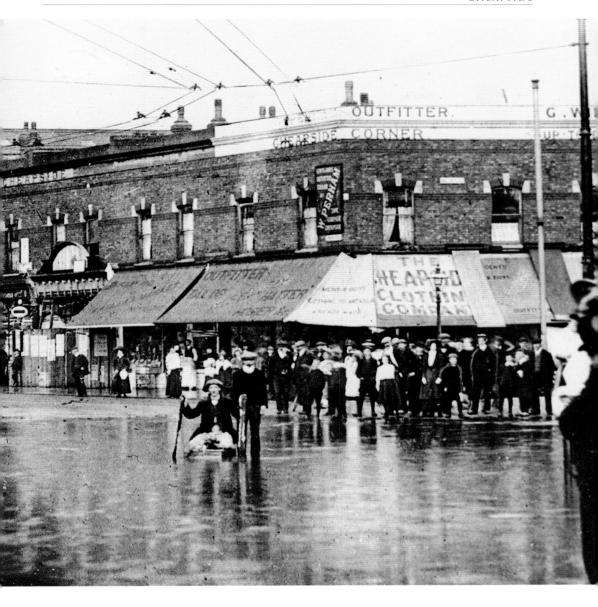

THE CORNER GROUP of shops was completely rebuilt in the 1970s and the layout of the roads remodelled to take into account the increase in traffic. Fortunately this redevelopment was reasonably sympathetic to the adjoining architectural styles.

LONDON ROAD

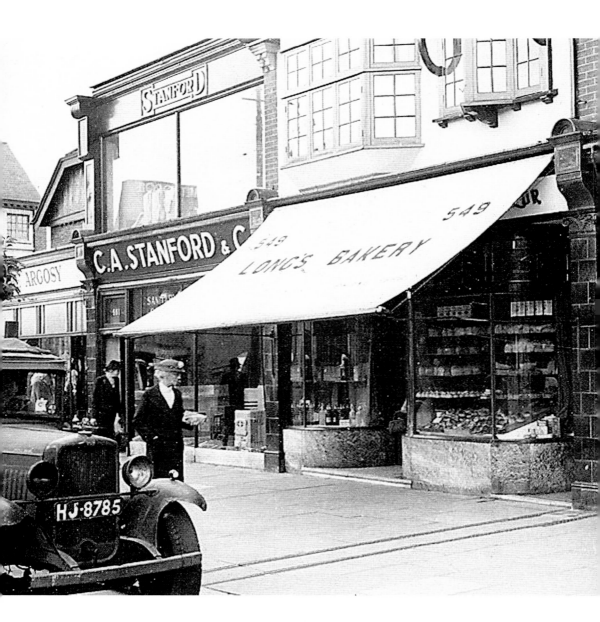

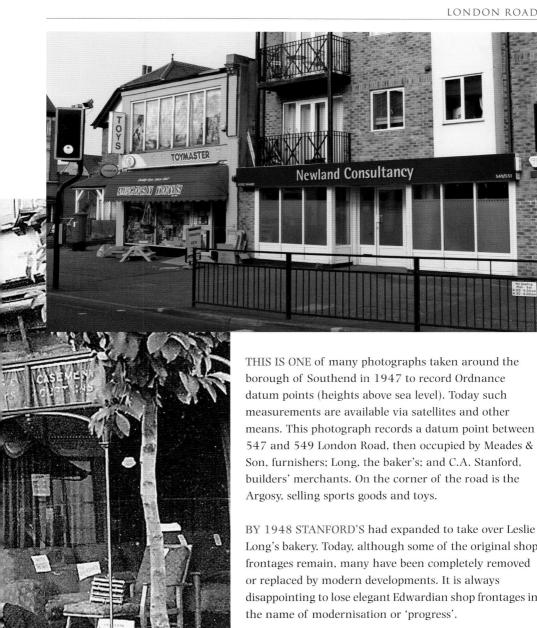

THIS IS ONE of many photographs taken around the borough of Southend in 1947 to record Ordnance datum points (heights above sea level). Today such measurements are available via satellites and other means. This photograph records a datum point between 547 and 549 London Road, then occupied by Meades & Son, furnishers; Long, the baker's; and C.A. Stanford, builders' merchants. On the corner of the road is the Argosy, selling sports goods and toys.

BY 1948 STANFORD'S had expanded to take over Leslie Long's bakery. Today, although some of the original shop frontages remain, many have been completely removed or replaced by modern developments. It is always disappointing to lose elegant Edwardian shop frontages in the name of modernisation or 'progress'.

HAMLET COURT ROAD

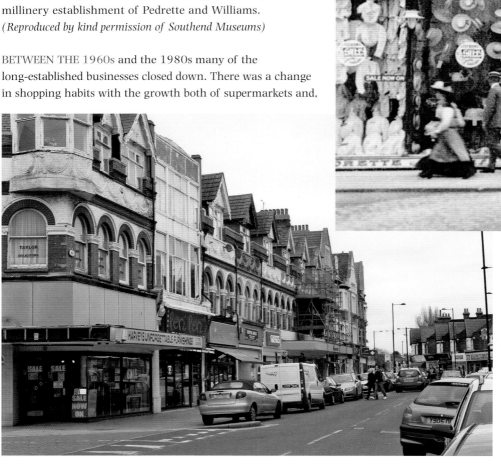

HAMLET COURT ROAD, decorated for the visit of the Home and Atlantic Fleets, 1909. This road was often referred to as Southend's second high street, with a number of specialist, elegant and high-class shops, including, for example, the millinery establishment of Pedrette and Williams.
(*Reproduced by kind permission of Southend Museums*)

BETWEEN THE 1960s and the 1980s many of the long-established businesses closed down. There was a change in shopping habits with the growth both of supermarkets and,

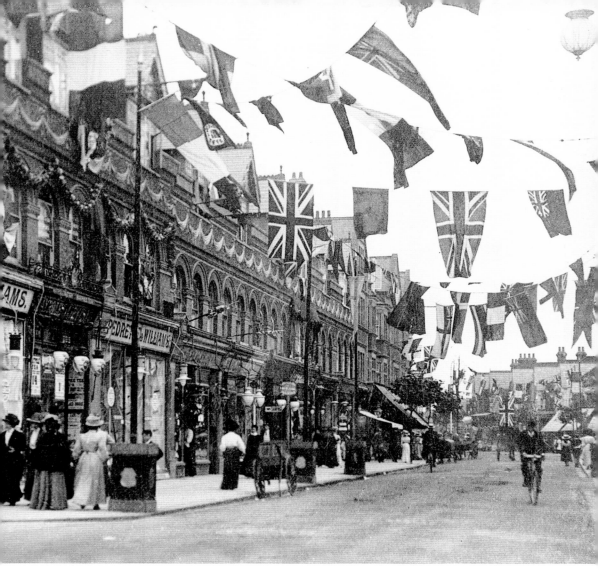

particularly, of out-of-town stores and retail parks. A result of this was the decline of Hamlet Court Road as Southend's second high street. Today, with considerable investment, this road has become attractive once again, with many of the original shop premises becoming restaurants.

WESTCLIFF-ON-SEA

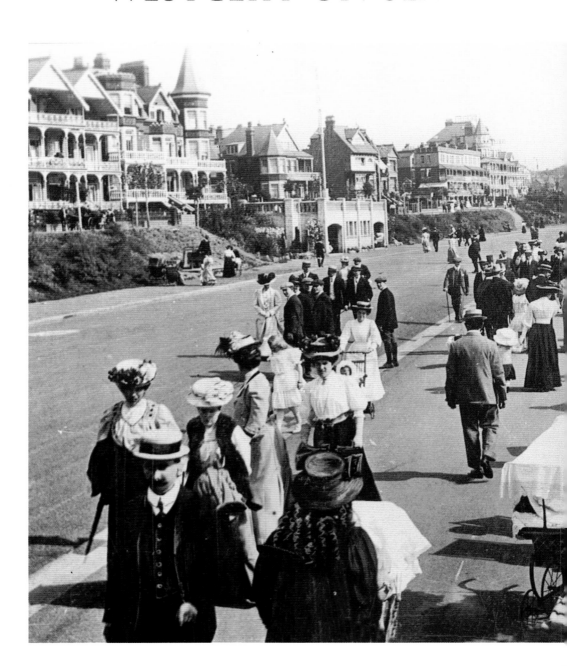

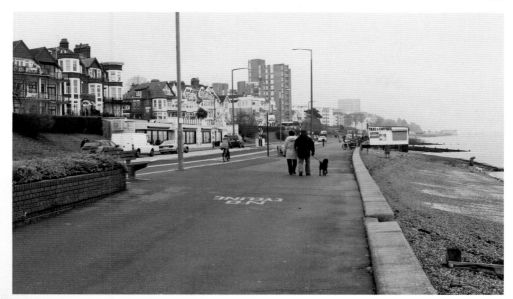

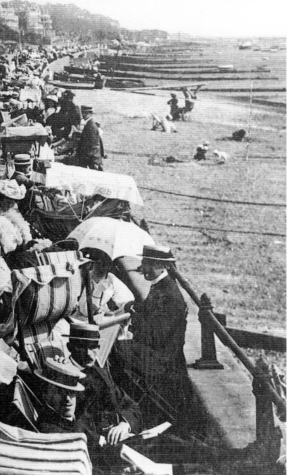

THE ESPLANADE AT Westcliff-on-Sea, probably *c.*1910. Here we see those people known as the 'better class of excursionists' by the local authorities, taking their stroll in the fresh air. Although there are a few people on the beach, sunbathing was still a long way in the future; most are promenading, and all are, of course, wearing hats.
(Reproduced by kind permission of Southend Museums)

WESTCLIFF SEAFRONT IS still a very popular place for 'promenanding' in both winter and summer. While dress may be different, the benefits of a stroll (or more vigorous exercise) along this very attractive promenade are well understood.

WESTERN ESPLANADE

AN INTERESTING VIEW of Western Esplanade *c*.1902, before the widening schemes were carried out. The sea wall was built in 1905. In the distance can be seen the Palmeira Towers Hotel, which was demolished in 1978.
(Reproduced by kind permission of Southend Museums)

IN THE EARLY twentieth century the Westcliff Promenade was laid out and

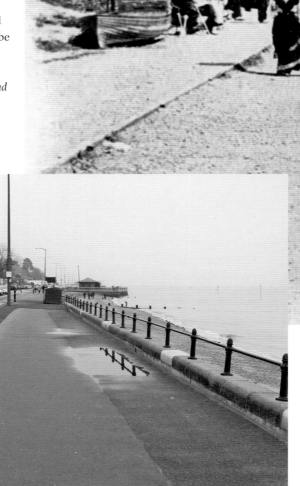

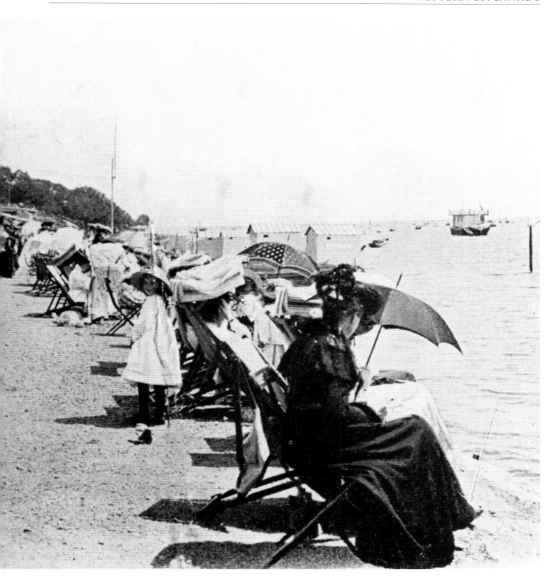

the sea wall was constructed, making it one of the town's greatest and most attractive assets. On the land side, many of the nineteenth-century buildings built on the cliffs have been replaced with apartment blocks.

BOATS, BATHING MACHINES AND JETTIES

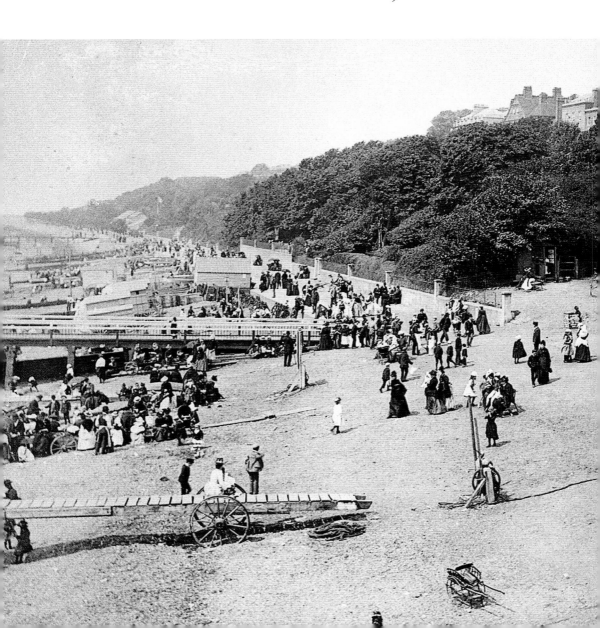

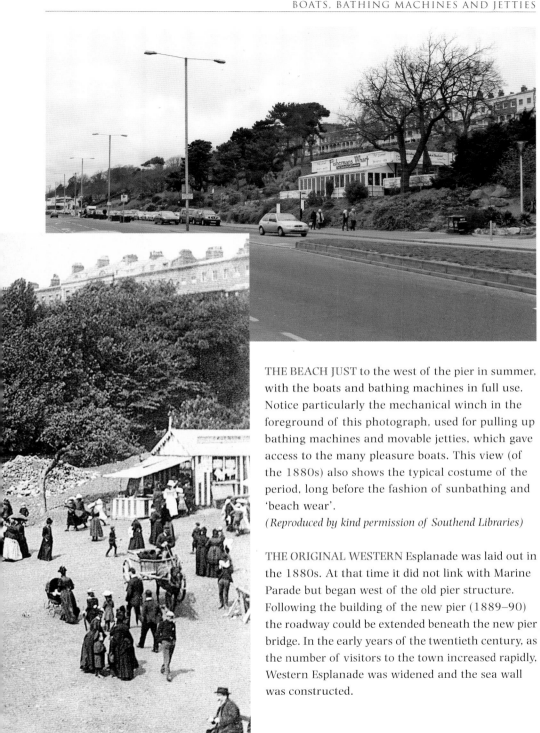

THE BEACH JUST to the west of the pier in summer, with the boats and bathing machines in full use. Notice particularly the mechanical winch in the foreground of this photograph, used for pulling up bathing machines and movable jetties, which gave access to the many pleasure boats. This view (of the 1880s) also shows the typical costume of the period, long before the fashion of sunbathing and 'beach wear'.
(*Reproduced by kind permission of Southend Libraries*)

THE ORIGINAL WESTERN Esplanade was laid out in the 1880s. At that time it did not link with Marine Parade but began west of the old pier structure. Following the building of the new pier (1889–90) the roadway could be extended beneath the new pier bridge. In the early years of the twentieth century, as the number of visitors to the town increased rapidly, Western Esplanade was widened and the sea wall was constructed.

THE PIER

THIS PHOTOGRAPH WAS taken by George Dawson during the Southend Regatta of 1900. So many people went on the pier during this festival that the authorities were concerned for the pier's structure. The brick entrance was originally built (in 1885) for the old wooden pier but was retained for the new 1889 pier.

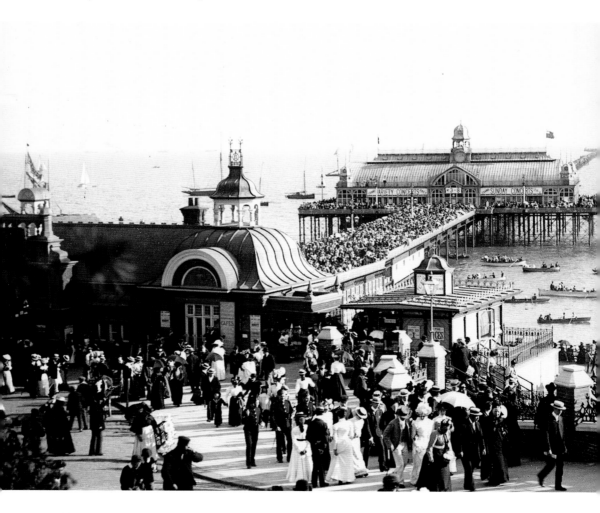

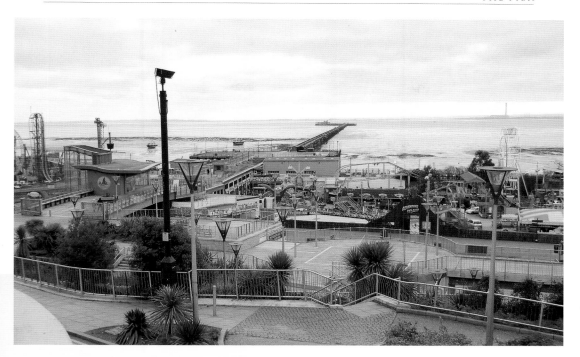

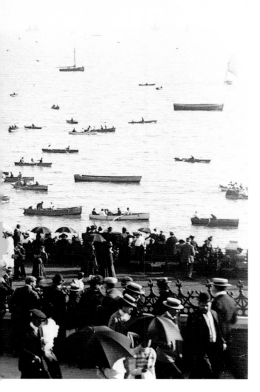

THE NINETEENTH-CENTURY brick entrance to the pier was demolished in 1931 and the pier entrance was refashioned at a higher level. The pier pavilion was destroyed in a fire in 1959, to be replaced by a ten-pin bowling alley, itself destroyed by a fire in the mid 1990s. In recent years the pier entrance and adjacent cliff gardens have undergone another major facelift, bringing this much-loved attraction into the twenty-first century.

SHOPS ON THE BEACH

A VIEW OF the beach immediately to the west of the old wooden pier, *c.*1880. This pier had originally been constructed in 1829–30, and in this view you can see the original entrance, little more than a shed. On the beach are a range of shops and stalls, including Ephraim Lawton's photographic studios and Ingram's warm baths to the left, in front of which are a number of bathing machines. *(Reproduced by kind permission of Southend Museums)*

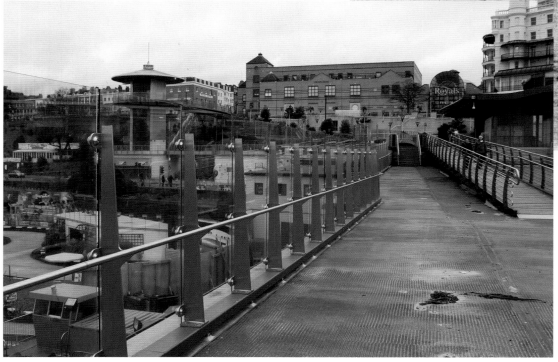

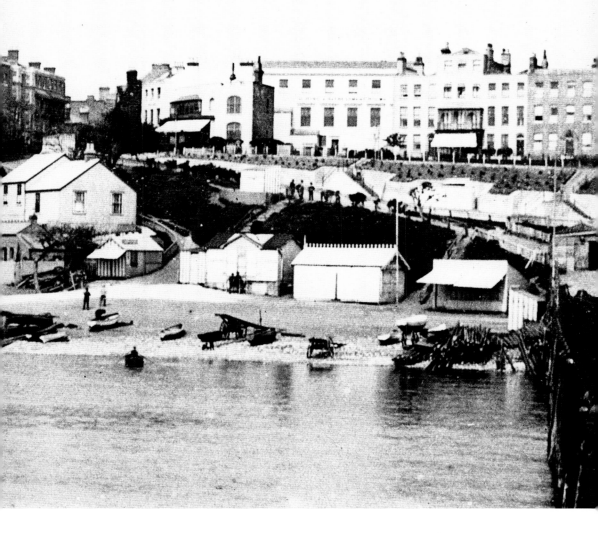

WITH THE BUILDING of the new iron and steel pier at a higher level in the late 1880s, followed by the construction of the improved Western Esplanade, the beach shops, stalls and hot-water baths were eventually removed. In the mid to late 1880s the old Grove Terrace had been demolished and replaced by the Grand Pier Hotel and other buildings. These were in turn replaced by the Royals shopping centre in the 1980s.

THE WATERCHUTE

IN 1902 A waterchute had been built on the east side of the pier by Mr Mann. It must be assumed that it was never a very popular attraction, for it was taken down in 1905.
(Reproduced by kind permission of Southend Museums)

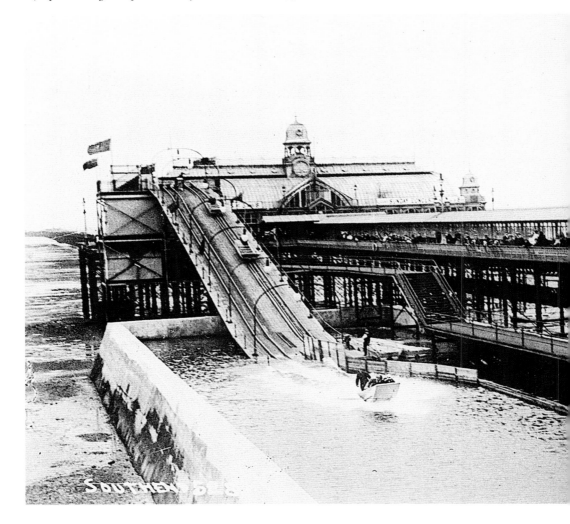

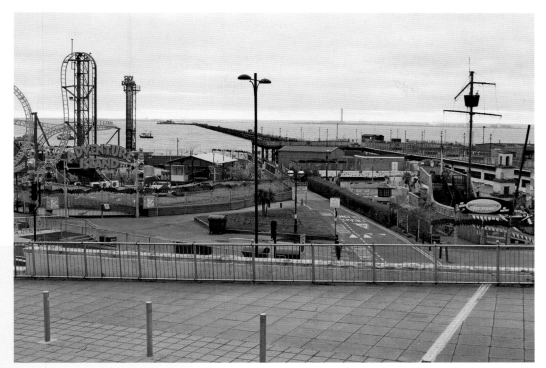

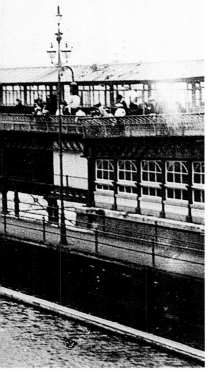

THE LONG AND fascinating history of Southend's famous landmark is told in Southend Pier Museum (below the shore station). The pier pavilion was destroyed in a fire in 1959. This was replaced with a bowling alley, which was destroyed in another fire in the 1990s. The Camera Obscura stood on this spot from late Victorian times but was removed by around 1930. The waterchute basin and the area to the left were developed by the Maxwells for the boating lake and later Golden Hind replica. In recent years this has become an extension to Adventure Island.

PIER HILL

THE UPPER LEVEL of Pier Hill with the Grand Pier Hotel on the right, Westcliff Motor Services to its left, and the Royal Stores (public house) and seafood stall on the corner. Just to the right of centre is the statue of Queen Victoria, which was the central feature of this area from 1898. In that year the statue was unveiled to commemorate the Queen's Diamond Jubilee. The statue was paid for by the mayor of the time, Bernard Wiltshire Tollhurst. Queen Victoria is seen pointing out into the estuary and to her empire. *(Reproduced by kind permission of Southend Borough Engineers Department)*

THE STATUE OF Queen Victoria was moved to the west, at the top of the cliffs, in 1962; a popular story is that some people objected

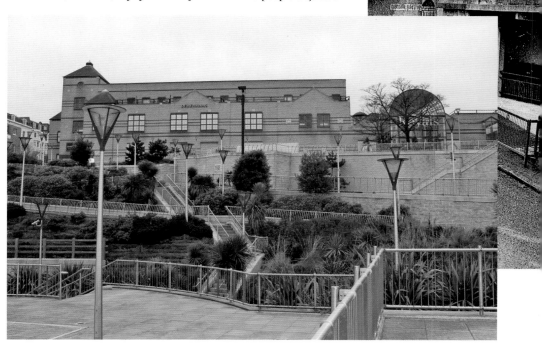

to its Pier Hill position because the Queen's finger was pointing directly to the public toilets. All of the cliff gardens in this area in more recent years have been refashioned and replanted, rejuvenating the whole of the Pier (or Royal) Hill landscape.

THE PALACE HOTEL

THE HOTEL METROPOLE was begun in the closing years of the nineteenth century, built for Mr Chancellor of Chelmsford and designed by James Thornton. Opening at Whitsun in 1904, the

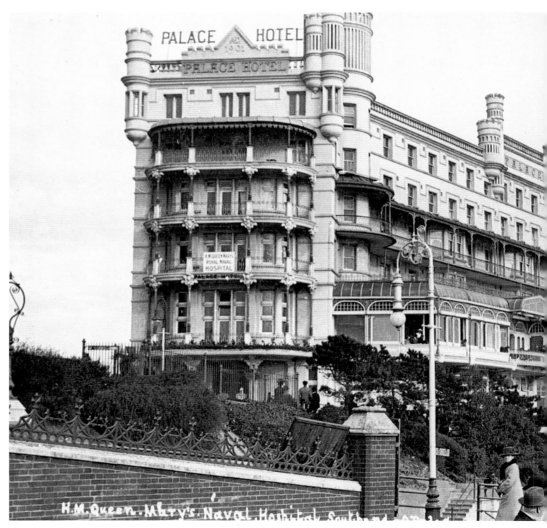

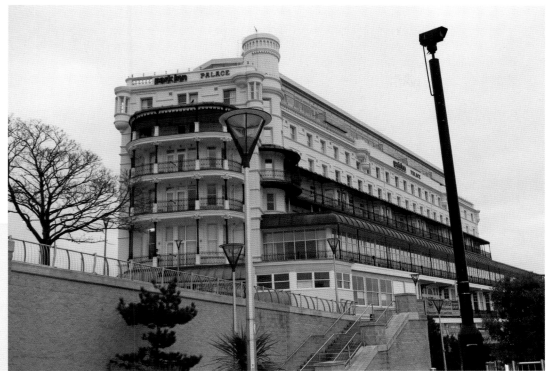

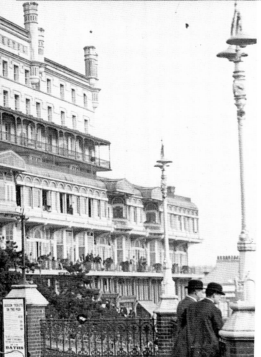

hotel had cost nearly £300,000. But this had been too much for Mr Chancellor and the scheme was rescued by Alfred Tollhurst, who purchased the building to open it as the Palace Hotel. At the outbreak of the First World War Alfred Tollhurst offered the Palace Hotel to the military authorities for use as a hospital. Thus, during the period of hostilities, the hotel was converted to the Queen Mary Royal Naval Hospital. *(Reproduced by kind permission of Southend Museums)*

IN RECENT YEARS the old Palace Hotel has undergone a major refurbishment, inside and out, under new owners, and has been reopened as the Park Inn Palace Hotel. An attempt has been made to restore as many of the original features as possible. From the hotel there are magnificent views of the pier.

THE LONDON PUB

IN THE LATE nineteenth century there were many complaints from those in favour of abstinence about the rowdy behaviour of drunken men and women in the High Street. The London pub was just one of the public houses frequented. In early February 1941 the London in High Street suffered a direct hit from a German bomb. Much of it was destroyed. In the raid of 19 October 1942 the adjacent premises of R.A. Jones, jeweller, and of Heddles' Cash Clothing Stores were also hit.
(Reproduced by kind permission of Echo Newspapers)

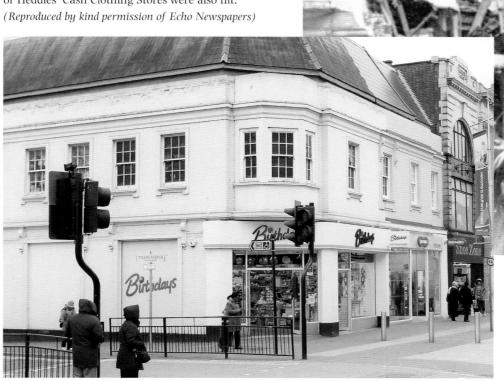

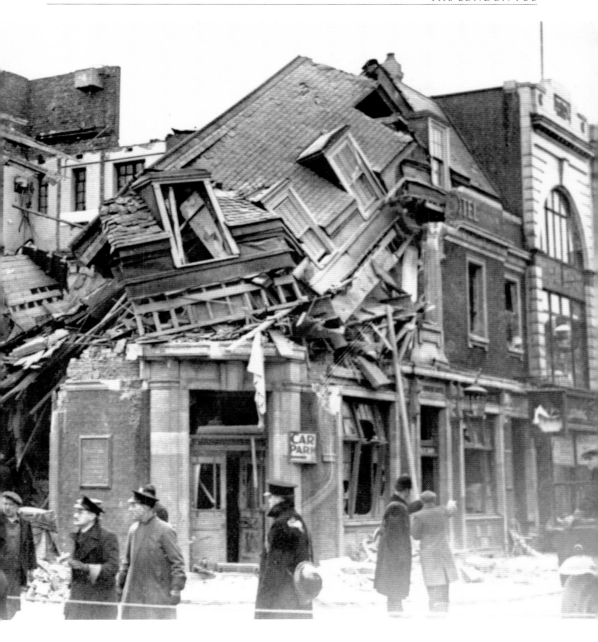

THE LONDON PUBLIC house was renamed The Tavern in the Town in 1969. This continued to serve as a public house until 1983. The premises were then largely rebuilt to a similar style and reopened in 1985–6 as Clinton Cards.

THE CHILDREN'S BOATING LAKE

THE CHILDREN'S BOATING Lake, east of the pier, was constructed in 1929–30, in time for the 1930 summer season. This was part of the project to build a sea wall and roadway under the pier and to enclose the sunken gardens on the west side of the pier. The boating pool was leased to J. & T. Maxwell, initially for a five year period. The new facility first appeared in Southend's official guidebook in 1931.

(Reproduced by kind permission of Southend Museums)

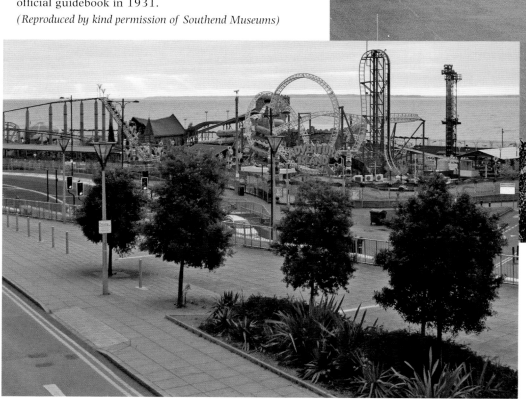

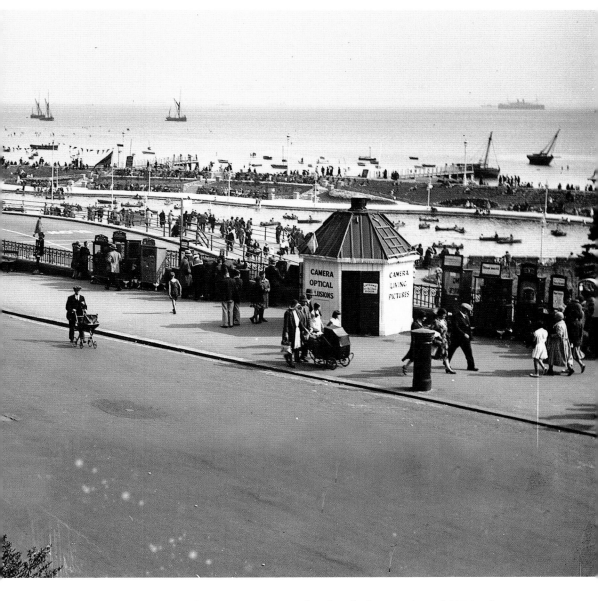

FOLLOWING A DRASTIC decline in visitors to Southend in the late 1960s and 1970s, the boating lake became disused and lay derelict for many years. Eventually it was drained, concreted over and the space used to create an extension to Adventure Island, which opened here in 1998. The Camera Obscura appears to have been removed before the Second World War.

MARINE PARADE

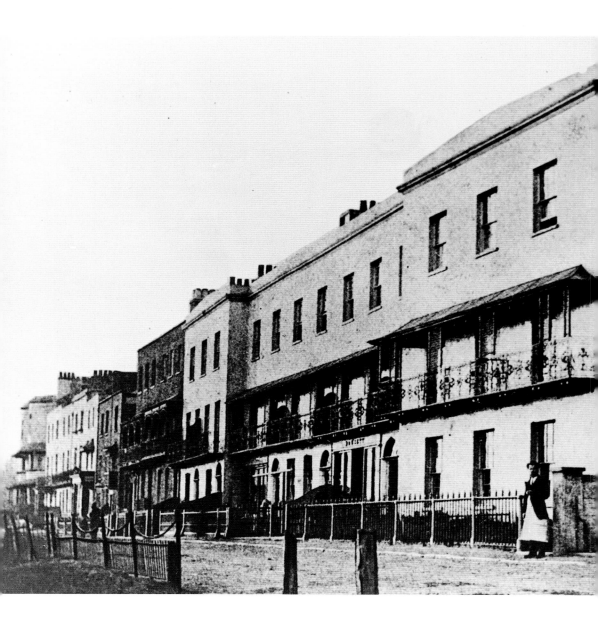

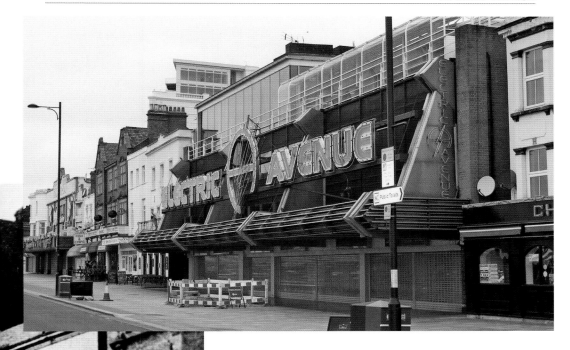

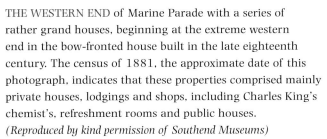

THE WESTERN END of Marine Parade with a series of rather grand houses, beginning at the extreme western end in the bow-fronted house built in the late eighteenth century. The census of 1881, the approximate date of this photograph, indicates that these properties comprised mainly private houses, lodgings and shops, including Charles King's chemist's, refreshment rooms and public houses.
(Reproduced by kind permission of Southend Museums)

ALTHOUGH MANY ALTERATIONS have taken place along Marine Parade since 1900, some of the original architecture remains above the shop fronts and amusement arcade frontages. One of the most notable changes, however, has been in the layout of the roadway itself.

MARINE PARADE, LOOKING EAST

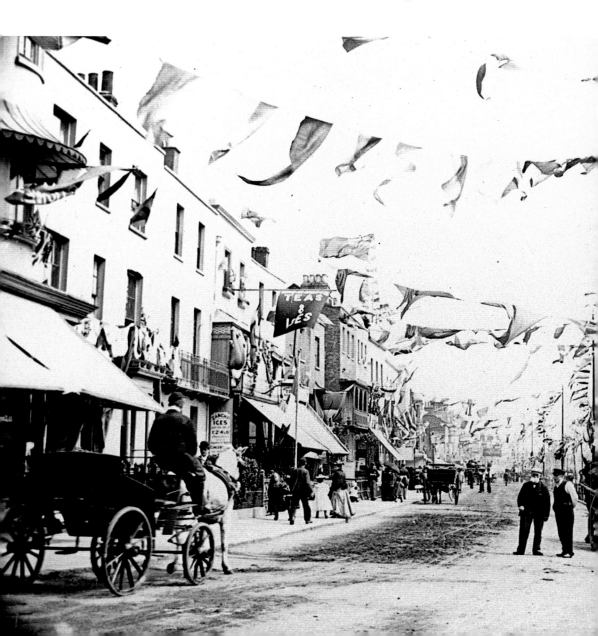

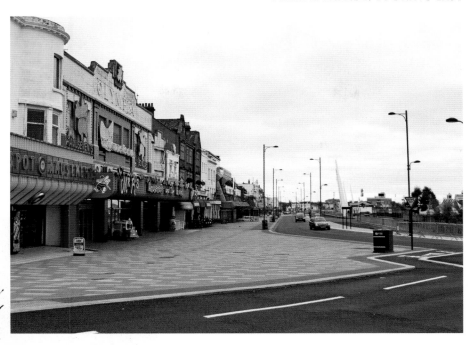

LOOKING EASTWARDS ALONG Marine Parade, *c.*1897. Although we cannot be certain, it is likely that the flags are in celebration of Queen Victoria's Diamond Jubilee in that year. On the right is a water cart, with the words 'Corporation of Southend-on-Sea' on the back, an indication that the photograph was taken after the creation of the Municipal Borough in 1892. We can also see that the photograph predates the widening of the seafront road, at the beginning of the twentieth century. *(Reproduced by kind permission of Southend Museums)*

IT HAS BEEN almost exactly a century since the first of the Marine Parade improvement schemes at the beginning of the twentieth century. Today (2011), another Marine Parade improvement scheme, the 'City Beach', will be completed. The road layout has been modified and in the distance the giant lamp standards that will illuminate the area at night can be seen.

MARINE PARADE,
LOOKING WEST

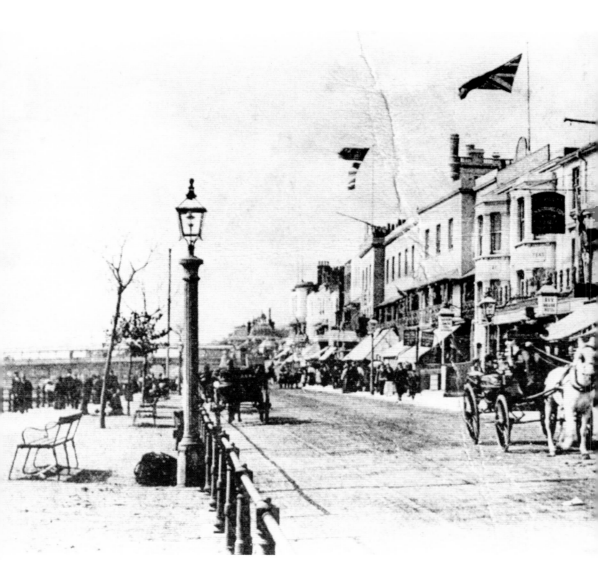

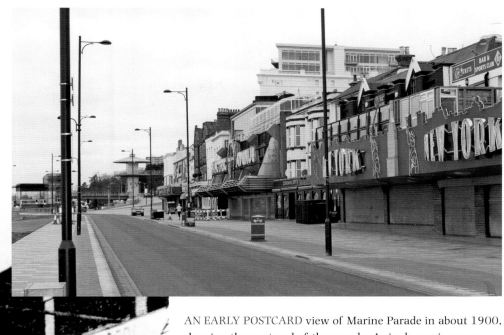

AN EARLY POSTCARD view of Marine Parade in about 1900, showing the west end of the parade. A single carriageway was divided from the beach by a simple iron railing. This was the Lower Town of Southend, that part to which the 'lower classes of excursionists' were confined and where all their needs were met – according to the local council, who wished to keep the western part of the seafront (west of the pier) for the 'better class' of visitor. So here, in the east, were the amusements, the shooting galleries, coconut shies and aunt sallies and, indeed, many of the shops and public houses. The shops included Luigi Offredi's refreshment rooms (at No. 25 Marine Parade) and at No. 43, the shop of Henry Thomas Dowsett, provision merchant.

(Reproduced by kind permission of Southend Museums)

IN 1903 SOUTHEND Town Council had put forward a scheme for reclaiming a large amount of the beach and foreshore for the widening of Marine Parade. Eventually the road was laid out as a dual carriageway, and in recent years this road became the stage for 'boy racers' to impress their friends. Today the clock has almost gone full circle, with Marine Parade being laid out again as a single carriageway.

THE HOPE HOTEL

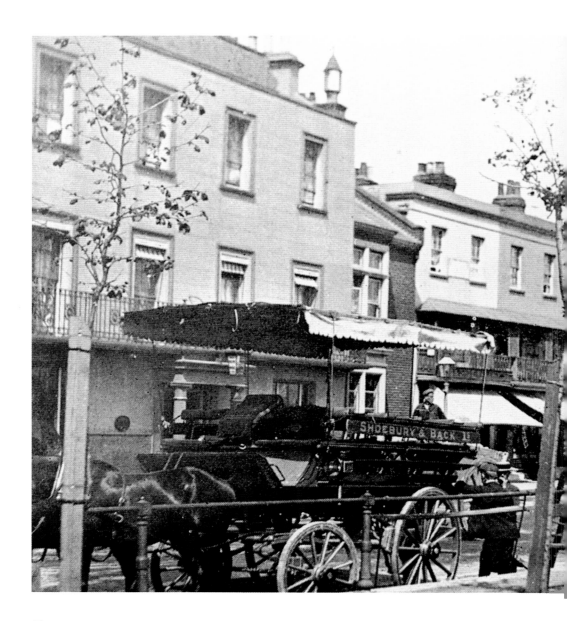

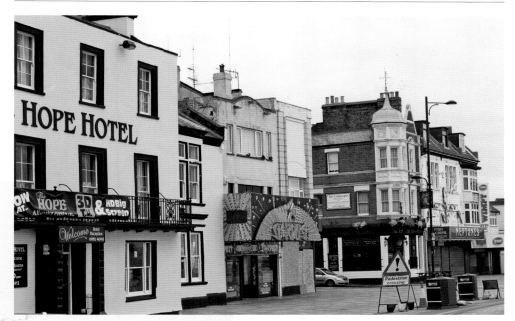

MARINE PARADE, *c.*1900. On the left is the Hope Hotel, built *c.*1790, and further along is the Cornucopia public house. In the foreground are the horse-drawn charabancs, which took passengers on rides to Shoebury and back. These may have been owned by the Triggs, who ran the Cornucopia public house. Due to the large number of such horse-drawn vehicles that plied their trade along this stretch of the seafront, it was also known as the 'Cart Parade'.
(Reproduced by kind permission of Southend Museums)

THE HOPE HOTEL is now the oldest surviving public house along Marine Parade. Apart from the central group of buildings, the architecture of this stretch of the seafront has remained largely unchanged and is an interesting mixture of eighteenth-, nineteenth- and twentieth-century styles.

THE FALCON

PROBABLY THE EARLIEST known view of Marine Parade, dating to about 1880. Taken from the west, we can see the Falcon public house (originally a private house, No. 4 Strutts Parade)

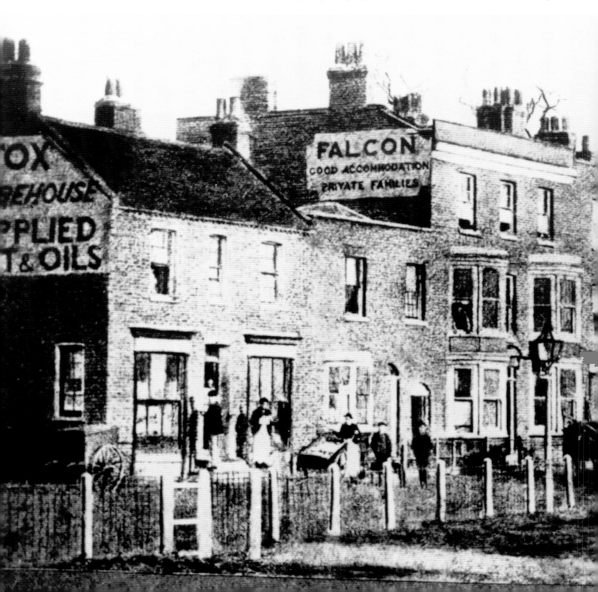

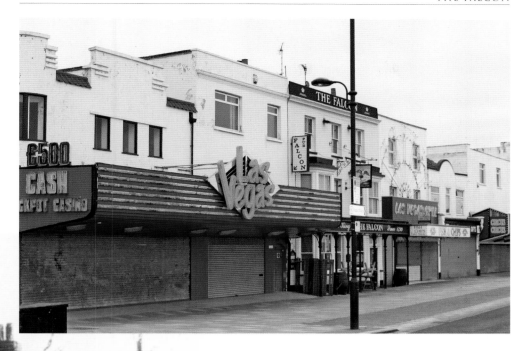

and, at the far end, the large and imposing Rayleigh House. At this time the whole of Marine Parade comprised private houses, lodging houses, pubs and shops. This particular stretch of the road was known as Strutt's Parade after its builder, John James Strutt, second Baron Rayleigh.
(Reproduced by kind permission of Southend Museums)

THE FALCON PUBLIC house still remains at the heart of this largely nineteenth-century group of buildings. The private houses, of course, have now been replaced by amusement arcades, souvenir shops and restaurants. The skyline however remains much as it was in the late nineteenth century.

THE KURSAAL AND REVOLVING TOWER

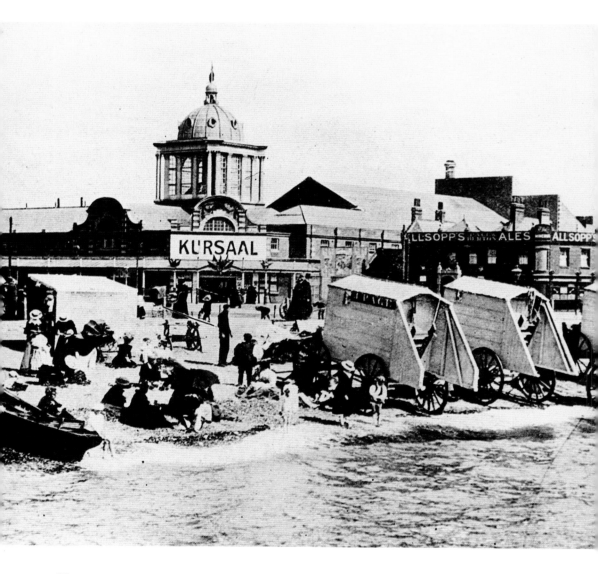

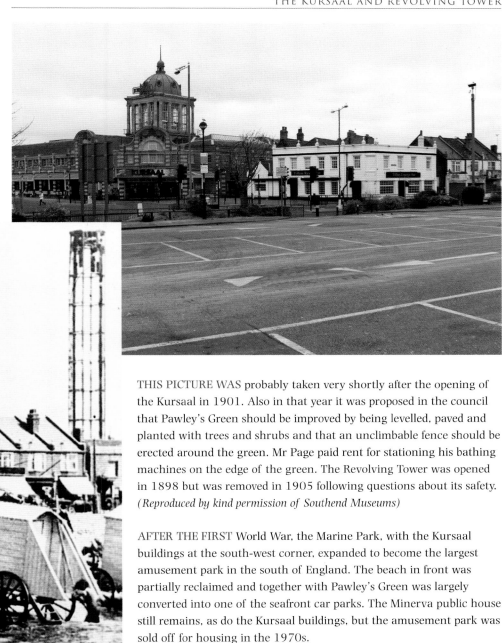

THIS PICTURE WAS probably taken very shortly after the opening of the Kursaal in 1901. Also in that year it was proposed in the council that Pawley's Green should be improved by being levelled, paved and planted with trees and shrubs and that an unclimbable fence should be erected around the green. Mr Page paid rent for stationing his bathing machines on the edge of the green. The Revolving Tower was opened in 1898 but was removed in 1905 following questions about its safety. *(Reproduced by kind permission of Southend Museums)*

AFTER THE FIRST World War, the Marine Park, with the Kursaal buildings at the south-west corner, expanded to become the largest amusement park in the south of England. The beach in front was partially reclaimed and together with Pawley's Green was largely converted into one of the seafront car parks. The Minerva public house still remains, as do the Kursaal buildings, but the amusement park was sold off for housing in the 1970s.

THE KURSAAL BUILDINGS REOPEN

THE KURSAAL WAS opened in 1901. These buildings stood at the south-west corner of the Marine Park. Originally the park was to be simply that, with bandstage, walks, gardens, lake and so on, but shortly before its opening the owners were persuaded to include a small 4-acre annexe for amusements. This proved so successful that other areas of the park were leased out for the erection of rides, and in 1896 plans were drawn

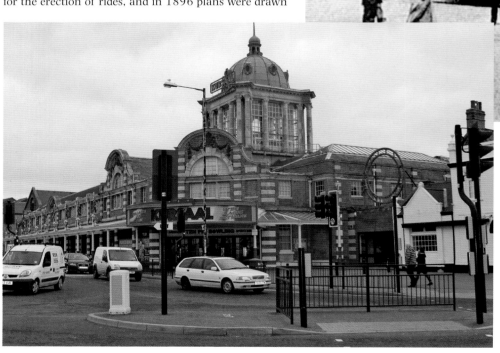

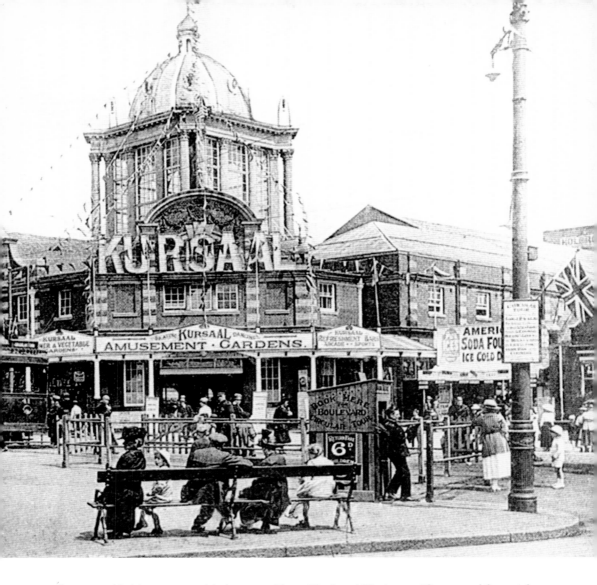

up for a grand brick entrance with domes and large Blackpool-like tower. After several financial failures the brick entrance and other buildings were eventually completed, but the tower was never built. The name Kursaal was adopted from the company that successfully completed the project – the Margate and Southend Kursaals Ltd – and it means a 'cure-hall', presumably intended to convey a place of healthy amusement in this case.
(Reproduced by kind permission of Southend Museums)

AFTER SEVERAL YEARS of declining attendances, the park closed in 1973 and was given over to housing. The Kursaal buildings eventually closed in 1986. Following many years of proposed developments but neglect, the site was purchased by Southend Council and the dome was awarded a Grade II listed protection. The Rowallan Group redeveloped the site, which eventually reopened as the Kursaal in 1998.

TO THE EAST

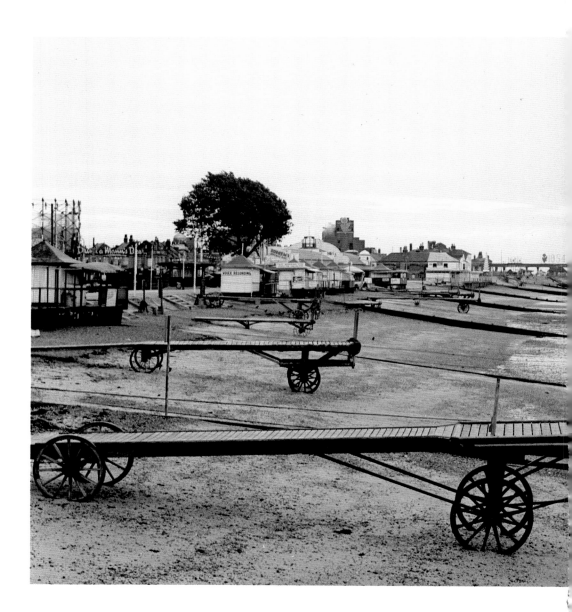

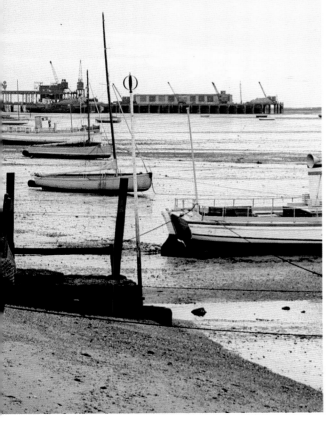

TAKEN IN 1954 (when the gasworks was celebrating its centenary), this view, looking eastwards towards Southchurch, shows the Corporation loading pier, the gasworks jetty, Prospect Place and the group of rather ramshackle stalls at the top of the beach. The wheeled jetties were a prominent feature of the beach in those days and were used to enable passengers to embark and disembark on and off the many passenger boats that would take you for trips 'around the bay'.

IN 1968 THE gasworks jetty became obsolete when natural gas was introduced. Shortly afterwards the jetty was demolished. The Corporation loading jetty had been little used since the 1960s and it too was demolished – although only recently – no alternative use being found for it. The moveable jetties have long disappeared with the small passenger boats, their trade having declined rapidly after the 1960s.

SOUTHEND'S BATHING MACHINES

A VIEW FROM the border with Southchurch, looking towards
the west (right). In the right foreground are the buildings of
Prospect Row and in front of them are the bathing machines,
which were a feature of all seaside watering places in the
nineteenth century. There is no real division between the
beach and the road. A loading jetty is in the middle distance,
with the masts of Thames barges just the other side.
(Reproduced by kind permission of Southend Museums)

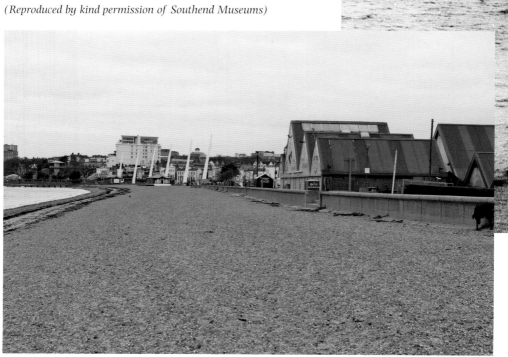

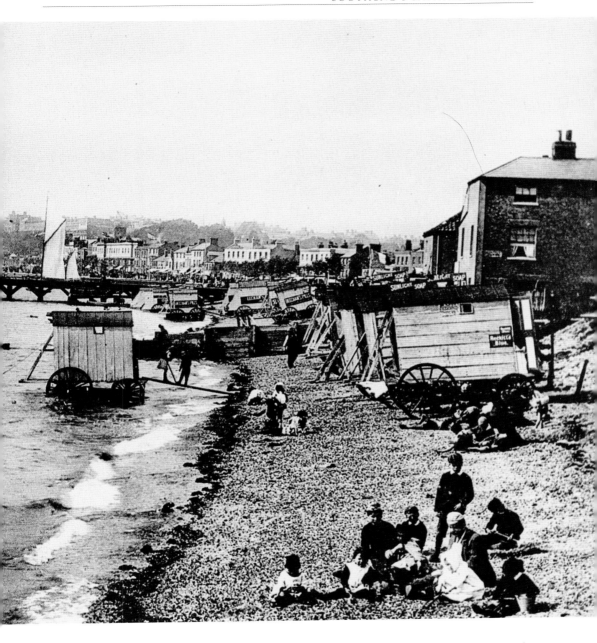

PROSPECT PLACE WAS demolished in the mid 1950s. A new sea wall was built to protect the area from future flooding. Long gone are the bathing machines, loading jetties and barges, which had once been such a feature of the seafront. Today the Sea Life Centre is the main attraction in this area.

PROSPECT PLACE

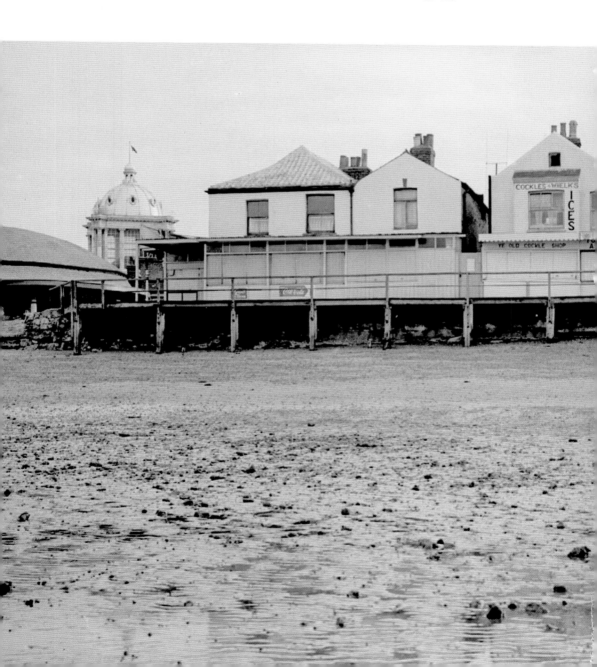

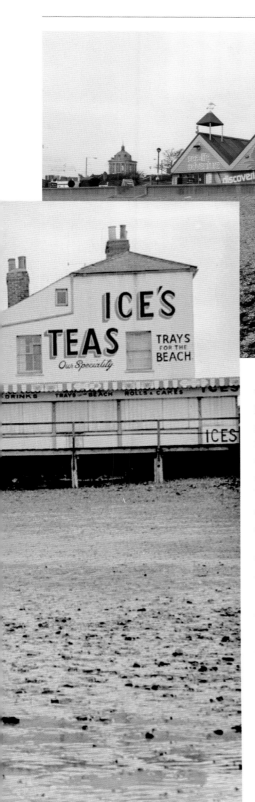

THIS GROUP OF buildings was a well-known landmark from the mid-nineteenth to the mid-twentieth century. By the early 1950s, when the left-hand photograph was taken, Prospect Place (incorporating Prospect Row) was occupied by shops, cafés and private dwellings. Around the front of the buildings was a raised wooden walkway, which can be clearly seen in this photograph, taken shortly before demolition.

THE BUILDINGS THAT made up Prospect Place were demolished soon after the disastrous floods of 1953. Although nothing was built directly on this site, apart from a new sea wall, a little to the east the Sea Life Centre was erected in the 1980s. The above photograph shows the western end of that attraction, with the Kursaal dome in the background.

93

PIER BRIDGE

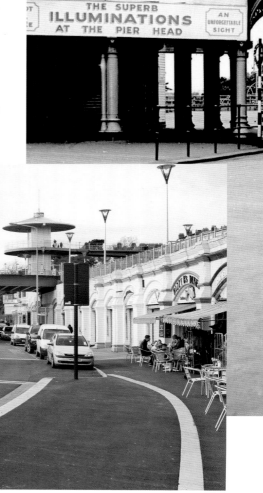

WHEN THE PIER was rebuilt in 1889, a bridge was built to connect the old brick entrance to the new pier. As you can see in this photograph from the mid 1950s, the clearance between road and bridge was 13ft 6in, allowing open-top buses to pass safely underneath (as long as you didn't stand up!). This didn't stop some bus drivers trying to squeeze the occasional double-decker underneath, which was never successful.

WITH THE REBUILDING and the renovation of the pier entrance and adjacent cliff gardens in recent years, the height of the bridge was raised. On the

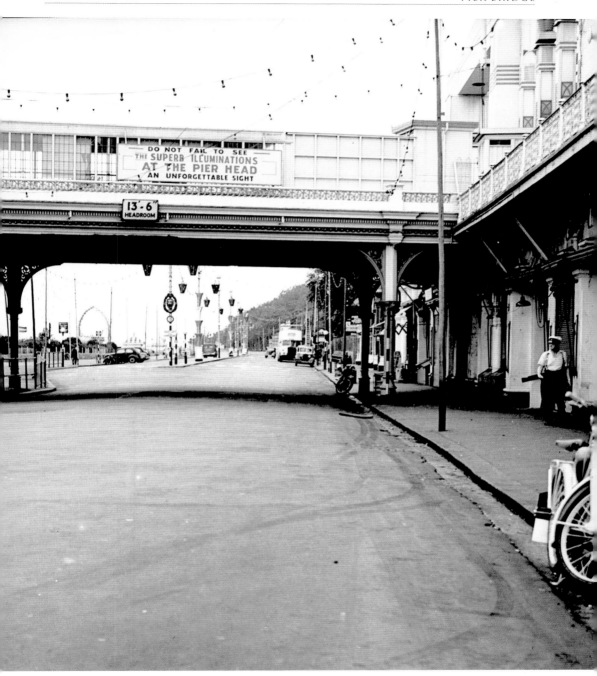

left can be seen the rather splendid entrance stairway from Marine Parade. This is also the entrance to the pier trains and Tourist Information Centre, with access to the Southend Pier Museum.

Southend Pier

MARTIN EASDOWN

As Sir John Betjeman famously put it, 'The Pier is Southend, Southend is the Pier'. Southend-on-Sea's famous landmark is the longest seaside pleasure pier in the world and has given its town sterling service in times of war and peace. Loved by millions of visitors, Southend pier is truly one of the icons of the British seasise. Martin Easdown's book is an extensive pictorial survey of the pier from its inception in 1830 up to 2007, celebrating 'the heart of Southend' and its everlasting appeal to both the town's residents and visitors alike.

978 0 7524 4215 0

Southend Memories

DEE GORDON

Including many conversations with Southendians, this title aims to recall life in their town, during the 1950s and '60s. It focuses on social change, as well as school days, work and play, transport, and entertainment. It also includes memories of the late '60s clashes between Mods and Rockers, and of the infamous Wall of Death at the Kursaal.

978 0 7509 4369 7

Southend at War

DEE GORDON

Dee Gordon's new book is the unique and fascinating result of many conversations with people about the lives of their families in Southend during the First and Second World War. Vivid memories are recounted, including interviews with former Land Army girls, evacuees, and members of the Home Guard. As well as recollections of life on the Home Front, archive reports and letters touch upon the horror of the conflict at the Front.

978 0 7524 5262 3

The Secret History of Southend-on-Sea

DEE GORDON

Southend-on-Sea, the largest town in Essex, has had an amazingly rich history, and this book collects together hundreds of little-known facts and anecdotes that will make you see the town in a new light. Discover the 'Brides in the Bath' murderer, the top-secret military operations performed just off Southend shore and the secret tunnels and smuggling dens used to hide guns, tobacco and Dutch gin. This captivating book will amuse and inform readers in Essex and beyond.

978 0 7524 9804 1